Haverford College Collection of Classical Antiquities
The Bequest of Ernest Allen

Ann Harnwell Ashmead

Published by
THE UNIVERSITY MUSEUM
University of Pennsylvania
Philadelphia 1999

for
Haverford College

Design and production
University Museum Publications

Printing
Sun Printing Company, Philadelphia

Cover design
Bagnell and Socha, Bala Cynwyd

Cover photography
Fred Schoch, University of Pennsylvania Museum, Philadelphia

Library of Congress Cataloging-in-Publication Data

Ashmead, Ann Harnwell.
 Haverford College collection of classical antiquities : the
bequest of Ernest Allen / Ann Harnwell Ashmead.
 p. cm.
 Includes index.

 ISBN 0-92-417169-3
 1. Classical antiquities. 2. Greece--Antiquities. 3. Pottery,
Greek. 4. Allen, Ernest--Collectibles--Pennsylvania. 5. Haverford
College. Collection of classical antiquities--Catalogs. I. Title.
 DF220 .A77 1999
 738.3'0938'07474811--dc21
 99-6077
 CIP

Haverford College Collection
of Classical Antiquities

With enduring gratitude to my
longtime friend and colleague,

Kyle M. Phillips, Jr.

Contents

LIST OF ABBREVIATIONS

AA — Archäologischer Anzeiger

ABL — C.H.E. Haspels, *Attic Black-figured Lekythoi*. Paris, 1936.

ABV — J.D. Beazley, *Attic Black-figure Vase-painters*. Oxford, 1956.

Addenda — L. Burn and R. Glynn (eds.), Beazley Addenda. Oxford, 1982. 2nd ed. 1989 (ed. T.H. Carpenter)

Agora — *The Athenian Agora, Results of Excavations Conducted by the Amercian School of Classical Studies at Athens.* Princeton, 1953–.

AJA — *American Journal of Archaeology*

AM — *Mitteilungen des Deutschen Archäologischen Instituts, Athenische Abteilung*

AntK — *Antike Kunst*

ARV² — J.D. Beazley, *Attic Red-figure Vase-Painters*, 2nd ed. Oxford, 1963.

AZ — *Archäologische Zeitung*

BABesch — *Bulletin van de Vereeniging tot Bevordering der Kennis van de Antieke Beschaving*

Boardman, Black Figure — J. Boardman, *Athenian Black Figure Vases*. London, 1974.

Boardman, *Red Figure: Classical* — J. Boardman, *Athenian Red Figure Vases: The Classical Period.* London, 1989.

Böhr — Elke Böhr, *Der Schaukelmaler*. Mainz,1982.

BSA — *Annual of the British School at Athens*

Corinth — *Corinth: Results of Excavations Conducted by the American School of Classical Studies at Athens.* Cambridge, Mass., 1929–.

CVA — *Corpus Vasorum Antiquorum*

Development, Revised — J.D. Beazley,. *The Development of Attic Black-figure* Revised edition. Berkeley, 1986 by D. von Bothmer and Mary Moore

GettyMusJ — *The J. Paul Getty Museum Journal*

Hesp. — *Hesperia: Journal of the American School of Classical Studies at Athens*

Higgins, Catalogue Br. Mus. — R.A. Higgins, *Catalogue of the Terracottas in the Department of Greek and Roman Antiquities, British Museum.* London, 1954.

Iacobone — Clelia Iacobone, *Le stipi votive di Taranto* (Scavi 1885–1934). Rome, 1988.

JdI — *Jahrbuch des Deutschen Archäologischen Instituts*

JHS — *Journal of Hellenic Studies*

Kurtz, AWL — Donna C. Kurtz, *Athenian White lekythoi: Patterns and Painters.* Oxford, 1975.

LIMC — *Lexicon Iconographicum Mythologiae Classicae.* Zurich, 1981–

MMA Bulletin — *The Metropolitan Museum of Art Bulletin*

MünMed — *Kunstwerke der Antike, Münzen und Medaillen*, AG, Basel.

NSc — *Notizie degli scavi di antichità.* Accademia Nazionale dei Lincei.

Para. — J.D. Beazley, *Paralipomena: Additions to Attic Black-figure Vase-painters and to Attic Red-figure Vase-painters*, 2nd ed. Oxford, 1971.

Payne, NC — H.G.G. Payne, *Necorinthia*. London, 1931.

RA — *Revue archéologique*

RM — *Mittelungen des Deutschen Archäologischen Instituts, Römische Abteilung.* Rome, 1886–

Winter — F. Winter, *Die typen der figürlichen Terrakotten.* Berlin, 1903.

FOREWORD

Ernest and I, the twin sons of Anna Detweiler and William Henry Allen, were born in 1919 in Alsace Township, Berks County, Pennsylvania, at the home of our maternal grandparents. We moved to Philadelphia in 1925, but not before Ernest and I had briefly attended the small one-room school house a little beyond our property.

We graduated from Central High School in Philadelphia in 1936 and from Haverford College in 1940. Ernest majored in Greek, graduating with honors. He worked briefly for the Provident Trust Company, but the war soon took him up. He saw service in the Field Artillery with the 26th (Yankee) Division at such exciting spots as the siege of Metz and the Battle of Ardennes. After the war he worked in Berchtesgaden with the Göring art collection for several months, eventually being mustered out as a captain. Under the auspices of the GI Bill, he then studied law at Columbia Law School. Upon graduation he moved to Tarrytown, New York, and joined Ernest F. Griffin, a college classmate of our father's whose law firm was the oldest in West Chester County. He remained in Tarrytown for the rest of his life and was involved in every sort of education, political, and social activity imaginable.

Our father, an MA from Columbia College, was probably the earliest to influence my brother toward an interest in ancient Greece since he required that all his children study the Classics. More influential was L. Arnold Post, Professor of Greek at Haverford, a man of many abilities. I don't believe that Ernest read much Greek after graduation but he was always interested in the culture. He began his collection rather by chance when some items from the estate of S. Weir Mitchell, a famous Philadelphia neurologist and novelist, were sold at a local auction house in 1941 or 1942. A beautiful red-figure amphora which he couldn't aspire to caught his eye, but he did get, at a price he could afford, a South Italian amphora made in imitation of Corinthian orientalizing pieces, probably EA-1989-13.

For some time after his initial purchase, study and the demands of his profession interfered with his buying. Then in the mid-fifties I became the American agent for Hesperia Art, a firm established by Robert E. Hecht, Jr., Haverford Class of 1941. As a result of my employment with the firm, Ernest found that he could buy pieces whenever he wished, and about once a year he would see some vase that took his fancy. Once in a while I tried to direct him to a piece I liked especially but he usually, and correctly, I might add, followed his own taste.

An occasional vase came from elsewhere. When we bought the library of Professor Samuel Chew of Bryn Mawr College, my mother noticed a white-ground lekythos among the books which she bought for him. On another occasion he happened to be at a flea-market in Reading, Pennsylvania, when he spotted an owl skyphos in a group of miscellaneous material offered for sale. He bought it for a few dollars and when the dealer told him he had another similar piece at home, Ernest had us going back for months to see if he ever turned up again. The dealer never did return and Ernest had to be satisfied with only the one flea-market treasure.

I think Ernest's greatest pleasure was in owning tangible objects from ancient Greece whose culture he so admired. He read the standard books on Greek vases but made no effort to become a latter-day authority. He occasionally went to see the collections at the Metropolitan Museum of Art or the University Museum of the University of Pennsylvania and it was in this way that he developed his appreciation for quality.

In the summer of 1988, my brother told me that he intended to give his collection of vases to Haverford College, to be called "The Ernest G. and George R. Allen Collection." I objected to the presence of my name since it was his collection but he insisted that I should share the billing with him. I believe he felt that whatever he amounted to in life he owed to the "small liberal arts college on the Main Line," as he sometimes referred to his alma mater, and that in donating the vases he would say thank you to the College with something that had meant so much to him. After his death, his widow, Victoria Taylor Allen, gave his collection to the College in his memory and it is now displayed in the Special Collections department of Magill Library in the same vitrine he kept it in during his lifetime.

George R. Allen
Philadelphia, 1991

PREFACE

In 1989 Ernest Allen bequeathed a small yet fine collection of Classical vases and terracottas to Haverford College. A selection from this bequest is now displayed in Allen's own antique glass cabinet in the Library's Special Collections. Allen gave a total of 25 items, which have been assigned a series of accession numbers: EA-(Ernest Allen), date acquired (1989), followed by the Estate Evaluation sheet number.* Ernest Allen had purchased most of his collection from Hesperia Art, a firm selling coins and classical antiquities. Hesperia Art was established by Robert E. Hecht, Jr., and managed by Ernest's brother, the late George Allen. Four vases were purchased locally: EA-1989-9 from the Estate of Samuel Chew, Professor of English Literature at Bryn Mawr College; EA-1989-6 from a sale of "college stuff" at Ursinus College ca. 1965–1970; EA-1989-12 from a flea market just outside of Reading, Pennsylvania; and EA-1989-13 (the first piece acquired for the collection) from the S. Weir Mitchell Estate sold by Freeman's Auction House, Philadelphia, in the early 1940s. The terracottas (EA-1989-18 through EA-1989-22) were purchased from the so-called Chapman Estate in the early fifties (probably that of Samuel Hudson Chapman [1857–1930]). Information about the provenance of the items comes either from Hesperia Art or a conversation with George Allen held in June 1990.

Ernest Allen purchased varied vase shapes, unusual subjects (an ephedrismos game, Hermes reclining on a ram, Peleus hiding up a tree) and a range of black- and red-figure artists. (All the vases, except the Theseus Painter's skyphos, EA-1989-6, were unattributed.)

This book proposes to introduce the Ernest G. and George R. Allen Collection to the general public and to provide data that will be useful to the scholarly community. We wish to thank Michael Freeman, Librarian of the College, for giving us permission to publish the pieces. We hope that the booklet, although a first for the Special Collections, will make these objects known to the wider audience that they deserve.

Geralyn Lederman, a Bryn Mawr College Ph.D. candidate in Classical and Near Eastern Archaeology, provided invaluable research assistance.

I would like to thank those who offered advice, guidance, and criticism: Andrew Clark (The Getty Museum), Joan B. Connelly (New York University), Keith DeVries (University of Pennsylvania Museum of Archaeology and Anthropology), Richard Green (University of Sydney), Richard Hamilton (Bryn Mawr College), Frances Jones (Curator Emeritus: Princeton Museum of Art), Philip Kendrick (Oxford, England), Jean MacIntosh Turfa (Bryn Mawr College), Margaret Mayo (Virginia Museum of Art), Machteld Mellink (Bryn Mawr College), Gloria Mearker (Princeton University), Joan Mertens (Metropolitan Museum of Art), Gloria Pinney (University of Chicago), Eva Rystedt (Medelhavsmuseet, Stockholm), Brunilde Ridgway (Bryn Mawr College), David Romano (University of Pennsylvania Museum of Archaeology and Anthropology), Anne Steiner (Franklin and Marshall College), Donald White (University of Pennsylvania Museum of Archaeology and Anthropology).

Ann Brownlee (Rutgers University) and Gloria Ferrari Pinney (University of Chicago) kindly read the rough draft of this manuscript and made many helpful comments.

I owe warm thanks to the library staff of Haverford College for their unfailing assistance during the study of the pieces: especially Diana Franzusoff Peterson, Special Collections (Quaker Collections, Manuscripts Cataloger), and Bruce Bumbarger for his fine study photographs. Further thanks to Georgianna Grentzenberger for her profiles and line drawings; and Åke Sjoberg for his faithful courier service. Karen Vellucci, Assistant Director for Publications, University of Pennsylvania Museum of Archaeology and Anthropology, undertook the task of editing and publishing the manuscript as well as improving the Mycenaean entries. Her careful scrutiny saved me from some errors and inconsistencies.

On a light note we observe that, appropriately enough, Haverford College's colors are Black and Red, the basic colors of many of these vases.

This catalogue has been made possible with the generous support of Anne Franchetti.

*One vase listed on this sheet (EA-1989-10), an Attic red-figure chous, a youth with horse, circa 460 B.C., *Hesperia Art Bulletin* 7, no. 216, Tarquinia Painter, *ARV²* p. 871, no. 91, did not come to Haverford but was retained by Ernest Allen's widow in Tarrytown, N.Y., and recently sold through Sothebys.

Please note that the figures in the decorative scenes are numbered from left to right. The side A/side B distinction is made arbitrarily: side A may be the better preserved, the more interesting, or the more carefully executed.

MYCENAEAN JARS

MYCENAEAN STIRRUP JAR

Figure: 1
Accession number: EA-1989-16
Painter: Unknown
Date: LHIII A2, mid-fourteenth century B.C.
Source: Purchased from Robert Hecht.
Dimensions: H. 0.095; D. of body 0.097; Spread of handle 0.060;
 D. of base 0.033; H. of spout 0.023 m.

MYCENAEAN SIDE-SPOUTED JAR (GUTTUS)

Figure: 2
Accession number: EA-1989-24
Painter: Unknown
Date: LHIII A2, mid-fourteenth century B.C.
Source: Unknown.
Dimensions: H. with handle 0.105; D. of mouth 0.035;
 Length of spout 0.035; D. of base. 0.031 m.

The earliest pieces in this collection are the Mycenaean stirrup jar and side-spouted jar, both dating to the Late Helladic III A2 Period (LHIII A2), in the middle of the fourteenth century B.C. This marked a period of increased Mycenaean commercial expansion with examples of pottery found in mainland Italy and Sicily, in Egypt, on Cyprus, Asia Minor, and the Black Sea region.

Although examples of stirrup jars are known prior to LHIII A2, it was at this time that the shape became popular and is found in increasing numbers at Mycenaean sites and at trading centers throughout the region. By this time, the decorative patterns on Mycenaean pots followed fairly standardized patterns depending on their shape. Large stirrup jars were used for the transport of oil and wine. Smaller examples, like this one in the Haverford collection, could have been used in bathing to hold perfumed oils. The size and shape would have been suitable for this purpose—by holding the hand palm up and inserting the second and third fingers into the handle the vase could be tilted to pour oil into the palm without any spilling. The name orginates from stirrup-like shape of handles.

The type of small side-spouted jug, though often referred to as a "baby feeder," could well have been used to dispense perfumed oil.

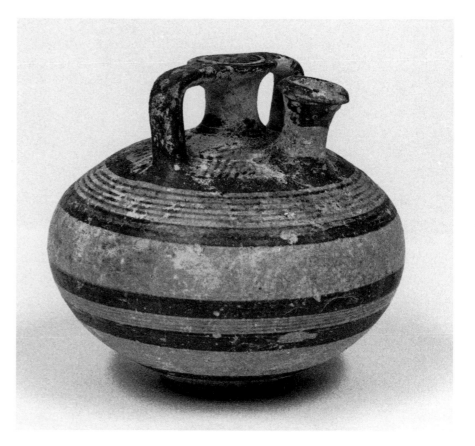

Figure 1 EA-1989-16. Mycenaean stirrup jar. Mid-fourteenth century B.C. Spout view.

MYCENAEAN STIRRUP JAR
(EA-1989-16)

CONDITION

Complete with no breaks. Base ring chipped slightly. Some encrustation on body.

TECHNIQUE

Clay Buff-colored clay with few inclusions. Decoration applied in thin lustrous reddish brown glaze. Wheelmade.

DECORATION

Body glaze decoration typical for the stirrup jar: on the upper and lower body, three groups of fine horizontal lines flanked by single wide bands. On the shoulder, five groups of chevrons. Handles glazed on exterior, but their undersides are reserved. Top of false mouth glazed, exept for reserved ring near rim; stripe around base. Spout rim glazed; crude stripe encircles top and base. Underside unpainted. The reserved band at mid-body, accents the fattest dimension of the jar.

SHAPE

Depressed globular false-necked jar.

COMPARANDA

Furumark, shape 178: Arne Furumark, *Mycenaean Pottery: Analysis and Classification* (Stockholm, 1972) p. 614, form 46, shape no. 178. See also P.A. Mountjoy, *Mycenaean Decorated Pottery: A Guide to Indentification,* (Paul Åstroms, Göteborg, 1986), fig. 94. Close parallels to this stirrup jar in both shape and decorative scheme are *CVA* Edinburgh 1, Great Britain 16 pl. 1, [718] no.1; British Museum A987, *CVA* London 5 [7], pl. 10, [294] 17.

For stirrup jars as containers for shipping oil see H.W. Haskell, "Pylos: Stirrup Jars and the International Oil Trade," *Pylos Comes Alive,* ed. by C. Shelmerdine and T. Palaima (New York, 1984), p. 98.

MYCENAEAN SIDE-SPOUTED JAR
(GUTTUS)
(EA-1989-24)

CONDITION

Complete with no breaks. Some flaking of glaze.

TECHNIQUE

Mycenaean fine ware. Whitish buff clay with few inclusions. Semi-lustrous brown glaze. Wheelmade; handle added separately.

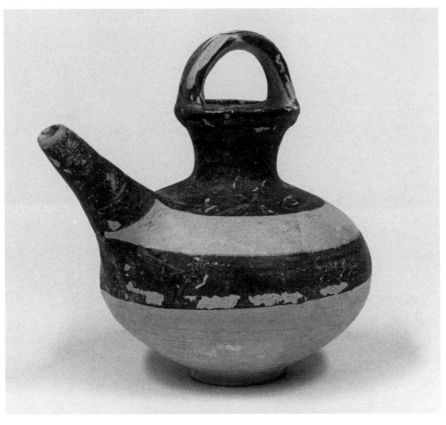

Figure 2 EA-1989-24. Mycenaean side-spouted jar. Mid-fourteenth century B.C. Left profile.

DECORATION

The decoration on the body consists of horizontal bands of thinnish brown glaze alternating with slipped clay. The strap handle is glazed along the edges only; in the center of the top is a glazed circle with central dot. The order in which the decorative glaze was applied is visible: the spout was painted first, then the neck and upper body bands, and the band encircling the jar at its widest diameter.

SHAPE

Side-spouted necked jar with basket handle, often called a guttus. Depressed ovoid body shape, splaying neck with rounded lip, tapering spout, ring base.

COMPARANDA

Furumark, shape 161: compare Furumark *op. cit.* p. 609, form 45, shape no. 161. For use, see K. Cook, "The Purpose of the Stirrup Vase," *BSA* 76 (1981), p. 166.

ANN ASHMEAD

CORINTHIAN TREFOIL AND GEOMETRIC OINOCHOE

CORINTHIAN GEOMETRIC OINOCHOE

Figure: 3
Accession number: EA-1989-17
Painter: Unknown
Date: Middle Geometric II, circa 800–775 B.C.
Source: Purchased from Robert Hecht, circa 1960
Dimensions: H. 0.215 m.; D. 0.175 m.; D. of base 0.109 m.

CORINTHIAN TREFOIL OINOCHOE

Figures: 4–5
Accession Number: EA-1989-13
Painter: Unknown. Recalls the work of Schistos and Geladakis Painters.
Date: 600–590 B.C.
Source: Lent to the University Museum, in 1917, by Mrs. John Kearsley Mitchell,
 daughter-in-law of S.W. Mitchell. Purchased ca. 1940, from the Estate of
 S. Weir Mitchell, at Freeman's Auction House, Philadelphia.
Dimensions: H. 0.356 m.; H.. to top of handle,0.416 m. D. of body,0.251 m.;
 D. of base 0.105 m.; Width of mouth, 0.164 m.

From the Geometric Period through to the end of the sixth century B.C. Corinth was one of the main centers for the production of Greek pottery exported throughout the Mediterranean world. Already in the Geometric Period, Corinth was at the hub of a far-ranging commercial network; Corinthian Geometric pottery has been identified at sites from Asia Minor to Etruria. The style was very popular resulting in many local imitations. Most Corinthian shapes were small—skyphoi were the most numerous—and decorated with a simple system of parallel lines and friezes of zigzags or vertical dashes setting off the different zones of the body. Proto-Corinthian style pottery introduced both new shapes and new decorative styles—the use of horizontal bands of motifs running around the pots—bands of animals, rosettes, birds, etc. Full Corinthian style increases the repertory of figural types and filler ornaments. Local imitations of these popular exports continued to be produced in many locales. It is possible for archaeologists to distinguish between true Corinthian pottery—objects actually produced at Corinth—and local imitations. Often the quality of the local drawing style is not accurate or the Corinthian decorative motifs have been applied to a local, non-Corinthian shape. But the surest way is by careful observation of the fabric itself; Corinthian pottery was manufactured from a distinctive local clay that produced a smooth buff fabric.

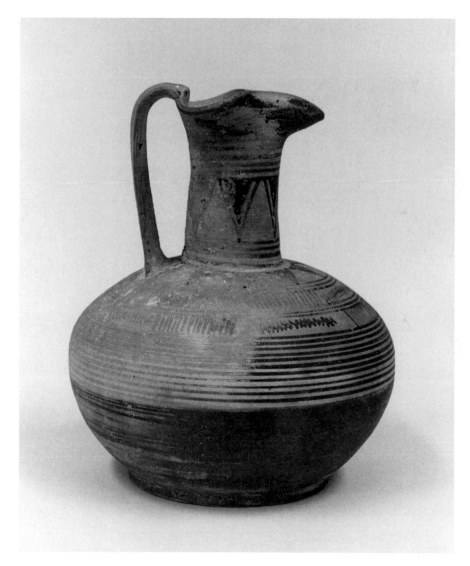

Figure 3 EA-1989-17. Corinthian Geometric oinochoe. Circa 800–775 B.C. Right profile.

The oinochoe, used to pour wine, was a popular shape in Corinthian pottery. The apportionment of light versus dark in the geometrically patterned oinochoe EA 1989-17—an even balance between the dark lower with the light upper body—suggests a Middle Corinthian Geometric date, as does the shape, and the placement of the decorative band just below the lower handle attachment. The mid body, lightened by means of horizontal lines, is a transitional zone from dark to light; black pendant triangles circle the neck and juncture to shoulder; at mid-shoulder are two bands, subdivided into panels, decorated with horizontal zig-zags alternating with groups of verticals, drawn with the multiple brush.

The pot body of EA-1989-13 is subdivided into three animal friezes. Near the center of the middle band, two panthers heraldically confront; between them is an outsized flower (heart of concentric incised circles), a mini version of an Eastern Tree of life. In the left half of this band, a panther confronts a browsing ram, in the r. half a large bird (a goose?); next a panther confronts a browsing goat. In the shoulder zone, are three animals: in the center a panther pacing right, between a ram and grazing long horned billy goat (steinbock:ibex?) moving left in the lowest zone are three pairs of panther (to right) confronting a browsing goat. Standard are the rays (twenty-two) around the base, the black zones overpainted with colorful red and white bands that separate the animal friezes, and the rich broth of rosette space fillers.

Although the task is daunting in Corinthian animal style, artistic hands have been identified, based on the evidence of animal physique, style of incision, location of added red paint and style, and quantity of the filler ornament. Idiosyncratic signature clues to this unknown artist are the row of tiny dots above the backs of some beasts, the cross-like bulge near the tail-tip of some panthers, the incised hairs along the rear upper leg of some panthers, the elongated panther torsos, elephant-trunk nose on left ram in middle zone, the thick fill of very large carelessly incised rosettes which contrast with the tiny dots, plus the rectangularish blobs.

Judging by its clay, black-glaze animal files, and typical Corinthian shape. (flaring trefoil mouth with narrow foot, ovoid body, fairly tall cylindrical neck and wide ribbon handle) plus style of animals, this oinochoe dates in the Later Early Corinthian–Early Middle Corinthian period.

DETAILS

CORINTHIAN GEOMETRIC OINOCHOE
(EA-1989-17)

CONDITION

Unbroken. Glaze flaked off at mouth.

TECHNIQUE

Clay Buff; white mineral deposits. *Glaze* Moderately lutrous black; fired red in lower body.

SHAPE

Plump, squat-globular oinochoe with trefoil mouth, fairly tall, straight-sided neck (neck and mouth twisted slightly to left); vertical band handle; low ring base.

DESCRIPTION

The mouth and lower half of the body are glazed black. Three lines separate the shoulder bands; lines circle the top and bottom of neck; four vertical lines down handle.

COMPARANDA

For balance of dark versus light and for type of base, compare Corinth T 2455. J.N. Coldstream, *Greek Geometric Pottery* (London, 1968), pl. 18a. However, the body of EA 1989-17 has an attractive squatness, unlike the rounder body of Corinth T 2455.

BIBLIOGRAPHY

Unpublished

ANN ASHMEAD

CORINTHIAN TREFOIL OINOCHOE
(EA-1989-13)

CONDITION

Broken, mended from numerous fragments. Missing: part of r. handle's roundel. Foot-rim: chipped. Considerable repainting at breaks with thick dull-black paint. Red: much faded. Incision reworked on shoulder of final goat (below handle) in middle frieze.

TECHNIQUE

Clay Yellowish-buff. *Glaze* Moderately lustrous black. Glazed are mouth (including interior of trefoil), neck, handle (exept for approximately 3 cm. above join to body), foot. Foot underside is reserved. *Added color: Red* Animal necks and manes, hindquarters, underbellies. Ram: dab on rib. Bird: wing bars, possibly alternate secondary feathers. Perhaps elsewhere, but obscured by overpaint. Narrow red band applied on black zones between animal friezes; a broader red band on black zone below. *White* Lines edge all red bands.

SHAPE

Ovoid bodied trefoil mouthed oinochoe. Tall ribbed handle composed of three ropes of clay backed by a plain flat strip, rising well above the rim, flanked at rim by rotelles. Fairly tall cylindrical neck. Grooved molding at top and bottom of neck. Small conical foot

BIBLIOGRAPHY

Published: *University of Pennsylvania, Museum Journal*, 1917, p. 188, and p. 189, fig. 72. (Lent to Museum by Mrs. John Kearsley Mitchell). H.G.G. Payne, *Necrocorinthia*, (1931) p. 298, no. 732; *Amercian Journal of Archaeology*, 22 (1918) p. 83.

Stephen B. Luce, *The University Museum: Catalogue of the Mediterranean Section*, (Phila. 1921) p. 56, no. 31C. Ann Brownlee called my attention to the *Museum Journal* publication of EA-1989-13, and the Luce references (see above) as well as the Amyx number error (see below).

COMPARANDA

SHAPE

For a discussion of the shape, see Payne, *NC* (London, 1931) p. 32, and p. 33, fig. 10E (Middle Corinthian) and D.A. Amyx, *Corinthian vase-painting of the Archaic Period* (Berkeley, 1988), hence *CorVP*, pp. 479–481, with bibliography. Amyx classifies this form of oinochoe with trefoil mouth and narrow foot as Shape IA; he describes it as very common, from the Late Proto-Corinthian Period, 650-640 B.C., onwards. Probably the potter of EA-1989-13 potted a very similarly shaped oinochoe with narrow foot attributed to the Schistos Painter: Corinth C-62-388: D.A. Amyx and P. Lawrence, *Archaic Corinthian Pottery and the Anaploga Well, Corinth VII, ii* (Princeton, 1975) p. 103, pls. 58 and 97, no. An22. and Amyx, (*CorVP, 218*) The use of a grooved molding at the juncture of neck with mouth is characteristic of the Schistos Painter (*Corinth VII, ii*, p. 89); pots by the Geladakis Painter lack this molding. According to Amyx the Schistos Painter only painted two oinochoe (*CorVP*, 218)

PAINTER

Compare animals to Schistos Painter. C.W. Neeft sees some stylistic similarity between the Haverford oinochoe and the early work of the Geladakis Painter, but prefers a comparison with the Schistos Painter (personal communication, May 1995). Compare the animal style to Schistos Painter's Corinth C-62-388: (*supra*) especially the frontal panther heads, fill motifs, and rib, shoulder, and haunch markings. See also the Geladakis Painter: Corinth T-1516. *Corinth XIII, ii*, p. 179, no. 155a, pls. A (colored) and 85. and Amyx, *CorVP* p. 215: A 40: a broad bottomed oinochoe; note dots along back of animals. In *Corinth VII,ii* p.89. the Geladakis and Schistos Painters' animals are described as "not unrelated;" in *CorVP* p. 218, the Schistos Painter is described as "closely related to the Geladakis Painter". Amyx situates the Geladakis Painter as a "younger companion of the Dodwell Painter" (Amyx, *California Studies in Classical Antiquity*, vol. 4 [1971] p. 29, and *CorVP* p. 214).

A more distant comparison for the Haverford oinochoe is amphora, London 1914. 10-30, Walters Painter, Payne, *NC*, pl. 23, no 5: see similar fill system: large rosettes that contrast with small dots, added angular blobs under some animal bellies, a crossed tail tip of feline.

BIBLIOGRAPHIC ERRORS

Because the Haverford oinochoe EA-1989-13 (Payne, *NC*, no 732) was displayed at the University Museum and published in the *Museum Journal* and because of mistakes in referring to similar numbers, the bibliography of the Haverford oinochoe and two similar oinochoe in the University Museum (MS 547 and MS 548 = Payne, *NC* no. 731) became involved. Confusion first arose when Amyx attributed University Museum oinochoe, MS 548 to "near the Painter of Tarquinia RC 1038" *CorVP* p. 144, but misnumbered it as MS 547. Although this number error was corrected by C.W. Neeft, *Addenda et Corrigenda to D.A. Amyx Corinthian Vase-Painting of the Archaic Period* (Amsterdam, 1991) p. 42. yet error crept back into J. L. Benson's *CVA* University of Pennsylvania 2 (USA 29) text: under MS 547, p.61: his first two bibliographical references (*MusJ* 8 (1917) 180, fig. 72 and *Necrocorinthia*, 298, no. 732) are wrong; these references are actually to Haverford EA 1989-13.

Neeft (personal comm. 1995) kindly clarifies the *attribution* conflicts in the Benson *CVA* text. The corrected references to the two University Museum oinochoe are as follows:

MS 548= *Museum Journal* 1919, p.11, fig.2 = Payne *NC* 731 = E.H. Dohan, *ITG, [Italic Tomb Groups, 1931]* p. 98, no. 3, pl. 52=Amyx *CorVP* p.144, no. B-1, no. 547 (error for no. 548) [Near the Painter of Tarquinia RC 1038] = Neeft, *CorVPAC*, 199 = Benson, *CVA*, MS548 [Walters Painter]. For Neeft attribution, see below.

MS 547 = (not in Payne *NC*) = Dohan, *ITG*, p. 98,no. 4 pl. 52 = (not in Amyx, *CorVP*) Benson, *CVA* MS547. Benson errs in attribution: probably misled by the number error (547) in Amyx's text, Benson writes that Amyx lists this oinochoe [MS 547] as "near the Painter of Tarquinia RC 1038"). Neeft writes that "a comparison with the Walters Ptr. and Ptr. of Tarquinia RC 1038 is more apt for 548 than for the wooden style of 547" (personal comm. May, 1995).

Because of the confusion we compared all three oinochoe: Haverford EA-1989-13 is closest to MS 548: both have comparable broader lowest black zone above rays, and the filling ornament is similar but the panther heads of MS 548 are finer than the Haverford oinochoe. As to shape, feet. are similar but MS 548 has a rounder body, a shorter neck.

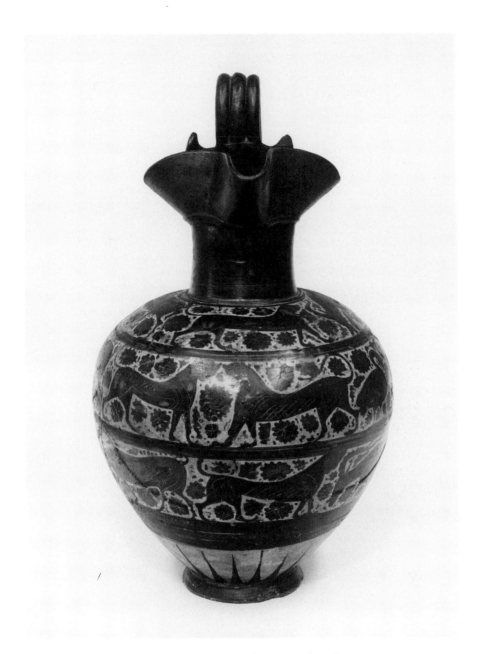

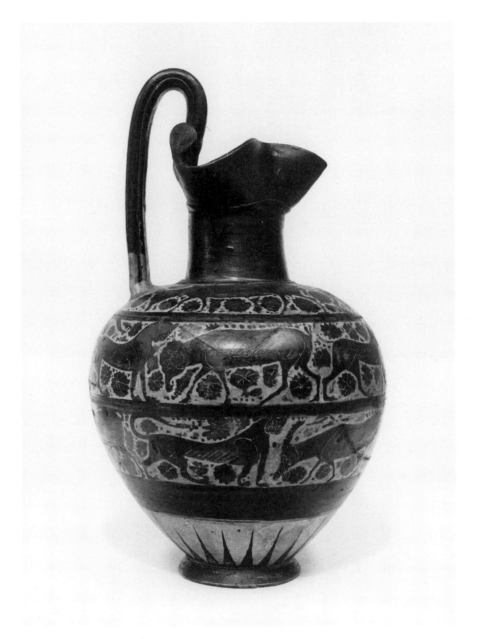

Figure 4 EA-1989-13. 600–590 B.C. Corinthian oinochoe. Front.

Figure 5 EA-1989-13. Corinthian trefoil oinochoe. Right profile.

ANN ASHMEAD

ATTIC BLACK-FIGURE LITTLE MASTER BAND-CUP

Figure: 6–7
Accession number: EA-1989-5
Painter: Attributed to the Elbows Out Painter by A. Ashmead.
Date: circa 540 B.C.
Source: Purchased from Robert Hecht, Hesperia Art.
Dimensions: H., 0.13 m.; D. of rim, 0.214 m.; D. including handles, 0.287 m.;
 D. of foot, 0.088 m.

Before the middle of the sixth century Attic Painters developed a miniaturist style admirably suited to small vases, and in particular cups. These cups are now known as Little Master cups. As the name implies, the figure work on this shape, a band-cup, is concentrated in a narrow band around the handle zone.

This shape, used to hold wine at banquets, first appeared about 560 B.C. and remained popular for more than 30 years. These cups project a new elegance, delicacy, and lightness—the foot has increased in height, the base of the foot has grown broad and flat, and the slightly concave lip runs into the line of the body.

This very typical example creates an impression of blackness, relieved only by the red (reserved) foot-rim, the animal zone, and narrow red accent band below. On each side are similar bird-friezes: three swans (displaying their wings) alternate with two hens (in profile); the side birds look centerward. The design is simple, formal, and decorative and was originally more colorful when the red and white of breasts and wings were fresh. The birds' movements are stereotypical, their shapes are archaic: the hens, puffed up to swan-size to fill the space, have exaggeratedly tiny heads and a long, stylized, continuous curve from head to tail; the swans have gracefully curved necks.

Many bands cups show animals—in fact animals are so frequent in the Little Master imagery that they must have played a fundamental role in the conception of these cups. Besides birds, there are rams, goats, stags, lions attacking bulls, panthers attacking deer, and sirens. Do these animals signify something? For example, the cock, (although missing among the birds of EA-1989-5) was a standard gift to a lover, both practical, since valued for cock-fighting, and an erotic symbol, since the cock was renowned for its virility.

A high proportion of good quality Little Master cups remain unattributed; in fact the attribution of this cup to a particular artist is a challenge. First, hens and swans look much alike, and only birds are portrayed on this cup; and second, because stylistic comparison between paintings on small cups and big pots is not easy. The artist must be Elbows Out (so called for the exaggerated arm gestures of his figures on his neck-amphora in the Louvre). The fowl on EA-1989-5 betray characteristics of Elbows Out (in tail shapes, sinuous necks, manner of using red, the close set white edging, parallel feather incision). Also hens and swans displaying their wings were a favorite image of his.

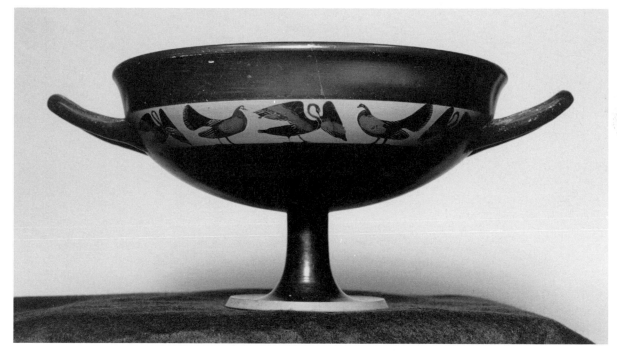

Figure 6 EA-1989-5. Attic Black-figure Band -Cup. Side A. Circa 540 B.C. Attributed to Elbows Out.

CONDITION

Broken into numerous pieces, but complete. Chip on foot caused by clay inclusion. Red misfiring on lip. On Side A, the more fractured, the left hen's tail is repainted, breaks repainted. Added red is peeling; white is very faded.

TECHNIQUE

Clay Typical Attic clay. *Potting* Bulges protrude inside at handle attachment sites. *Glaze* Glossy black. Lip, body, foot, and interior glazed on wheel. *Kiln Stacking* indicated by olive-gray discoloration, in band 5 mm wide, in black glaze below frieze. *Reserved* Band below frieze, foot-rim, foot bottom, narrow band on rim; insides of handles; small disk of interior, containing two concentric rings of dilute glaze with center dot (extra dot on reserved area is a mistake). *Color: Red* Bars on swan-wings (secondaries) and breasts of hens. *White* (very faint) Swans: edging their red bands. Hens: line contouring their wing secondaries, line edging base of tail-feathers. *Incision* Eye-circles, beaks, feathers, and swan-breasts.

BIBLIOGRAPHY

Unpublished

COMPARANDA

SHAPE

Little Master band cup: a fairly deep bowl with slightly offset lip, two horizontal handles, tall foot stem, and broad resting surface that is not flat but lifts up at rim.

For the shape, a favorite of Elbows Out, see J. Beazley, *Development, Revised* (Berkeley, 1986) pp. 48–49; and J. Boardman, *Black Figure* pp. 58–60. For animal friezes on Little Master cups: K. Vierneisel and B. Kaeser, *Kunst der Schale: Kultur des Trinken* (Munich, 1990) pp. 96–110.

PAINTER

Elbows Out: In brief, Boardman, *Black Figure*, pp. 64–65; Beazley, *ABV* 248–51. The Haverford band cup is a lesser work by the painter with no exact parallel. Stylistically, the nearest birds are swans and hens in company of a donkey, on a fragmentary band cup in the Bareiss Collection, Getty Museum no. 86.AE.168.1–2: *CVA*, Malibu 2 (USA

25) pl. 101, p. 54 (with bibliography) = D. von Bothmer, "Elbows Out," *RA* 1969, p. 14, fig. 10, and note 2. Also compare a swan and hen facing, on a band cup from Syracuse: *NSc* (1925) p. 205, fig. 42 (drawing); *ABV* 250, no. 34 (similar shapes of swan's tail, wing hatching, and manner of closely edging red with white). Similar too is the swan on shoulder of a lekythos by Elbows Out, in Athens, Vlasto Collection: Haspels, *ABL* pl. 7, 2, *ABV* 249, no. 14. Related, but much finer, in greater detail and more carefully drawn, are the nine fowl in a frieze (three groups of fighting cocks observed by a hen) on the artist's name piece, a neck-amphora, Louvre E 705: *ABV* 248, 4; *RA* (1969) p. 9, fig. 6–7. For a recent addition to Elbows Out's birds on cups see, cocks facing on band cup, Munich 2151, B. Fellmann, "Zwei neue Randschalen des Elbows Out Malers," *AM* 99 (1948) pp. 155–160, pl. 23.

SUBJECT

Hens and swans displaying their wings were favored by Elbows Out; see Joan Haldenstein, *Little Master Cups: Studies in 6th Century Attic Black-Figure Vase Painting: Dissertation* (University of Cincinnati, 1982) p. 41. For two cups with same subject as EA-1989-5: see 1) Sotheby's, May 17, 1983, no. 290; 2) Godalming, Charter House, band cup by Elbows Out (references from Joan Haldenstein). For a similar flock by other artists (three displaying swans, two hens, on both sides) see a band cup, in the London Market, illustrated in *Christie's Sale Catalogue* July 12, 1977, no. 136 (reference from Haldenstein, *supra* p. 160; no information on painter). A comparable flock on one side of a band cup, attributed to the Cassel Group, Cassel T 704, Staatlichen Kunstsammlungen, *CVA*, Cassel 1 [35] pl. 29 [1709] 3; pl 30 [1710] 3.

To illustrate how stylistically close birds by other artists can be, compare hens, roosters and swans joined by an owl next to the handle, on one side of band cup in Basel, attributed to Megara Painter, an artist in the Circle of Elbows Out: *Werke Antiker Kleinkunst: Katalog 2*

(Basel, 1990) p. 24, no. 43: but, the hatching on the backs of the hens of the Haverford cup is longer, closer and not always parallel. Compare swans and roosters on band cup, Athens no. 13108, by the Megara Painter (named by D. Kallipolitis-Feytmans): *CVA*, Athens 3[3] pl. 33 [131] 4–5; and fig. 13 (foot profile); drawing is hastier than Haverford EA-1989-5, but related; foot profile is similar. Compare band cup attributed to the Cassel Group: Cassel T 704, Staatlichen Kunstsammlungen, *CVA*, Cassel 1[35] pl. 29 [1709] 3; pl. 30 [1710] 3) for similar shape of swans and hens, neat incision, and white, closely edging the red.

Figure 7 EA-1989-5. Drawing of profile.

ATTIC BLACK-FIGURE EYE-CUP

Figures: 8–11
Accession number: EA-1989-3
Painter: Unnamed. Same painter as Louvre no. 139.
Date: circa 530–520 B.C.
Source: Purchased from Robert Hecht, Hesperia Art.
Dimensions: H., 0.10 m.; D. of bowl, 0.218 m.; D. including handles, 0.287 m.;
 D. of foot, 0.093 m.

This type of Attic cup is easily identifiable by its characteristic shape and large staring eyes on each side giving the vase the appearance of a face. The added white of the eyeballs and the red (now faded) ring of the pupil make the eyes shine out luminously. Above are curvaceous brows. Some eyes have a nose between and ears at the sides, creating a complete face, and when the cup is tilted, or hung, the foot resting surface creates the affect of an open mouth. Here, between the eyes, a youth is under homosexual siege by a bearded man.

Pairs of eyes have been explained as decorative or apotropaic, but a more convincing theory is that they may represent a Dionysiac face mask. Imagine oneself at a symposium, looking at a companion drinking. The cup "mask" that covers his face could be interpreted as the face of the god of wine, Dionysos, or one of his satyrs or maenads. By "masking," the drinkers at the symposium integrate with Dionysos or his cortege.

Courting couples are a popular scene in Attic black-figure vase painting, but only certain limited moments of courtship were illustrated. The major group, showing a man propositioning a youth, recurs with comparatively slight variations on many vases. These encounters are succeeded by scenes of gift giving, and finally of lovemaking.

Our courting pair (both once red-haired) face each other, the bearded lover (called the *erastes*) on the left as usual, the beloved boy being wooed (the *eromenos*) on the right. As this older lover propositions the youth, he bends his knees—also a typical pose—and raises his large left hand up to the youth's face, while reaching with his other towards the youth's thighs. His courting gesture is so standard that it is named the "up and down" position. Here the youth seems to draw back, reluctant, protecting his genitals with his right hand, his left hand held to his hip. A normal defense was to hold the *erastes* by the wrist. This "up and down" position is much more common in homosexual courtship than in heterosexual scenes.

The scene is repeated with minimal changes on the other side: the older man's right hand is palm up on the front, whereas on the reverse it is in the more common palm-down gesture; on the front a wreath hangs on the wall. A youth will sometimes hold a wreath, hang it over his arms or around his neck—its meaning is surely erotic. Both figures are naked (what seems to be a dress line, is the edge of the clavicles). Beneath each handle hangs an inverted lotus flower.

Erotic themes recur on eye cups: for instance, on one cup an erect phallos replaces the nose, and on another the base itself is turned into a phallos. Erotic couples, such as these, may suggest one relationship of the guests who will drink at the symposium. Moreover, the phallos is the symbol of Dionysos, the fertility deity and the god of wine whom Greek men would celebrate at stag parties.

It is misleading to equate homosexuality as we currently understand it with Greek pederasty. In Athens, sex was mainly between an adult man and a young boy, as on this vase. Pederastic love affairs were regarded by society as decent and normal. The youth was a passive partner, as here. Copulation was intercrural (between the thighs) only. Furthermore sex in Athens was not a private, joint quest for mutual pleasure, but rather a manifestation of personal status, a declaration of social identity. This sexual relationship reflects Athenian culture; one partner was dominant, socially superior, and the other submissive, socially inferior. An adult male citizen could have legitimate sexual relations only with his social and political inferiors, specifically, women, boys, foreigners, and slaves. But sex between the citizen elite was frowned upon. The popularity of these courtship scenes during the rule of the Peisistratids (550–500 B.C.) may be a reflection of aristocratic taste.

The Attic painter skillfully used decoration to enhance this cup's shape. The deep bowl sits solidly on a low blocky foot, almost curveless in profile. Although these vase parts are unequal, the dark and light decorated zones of the cup are almost in balance. Furthermore, the artist has skillfully avoided abrupt harsh contrasts where red meets black, by applying black lines above and below the scene. The wide reserved band in the glazed lower bowl softens the black, and its effect is echoed by the edge of the foot-rim. Black glaze accents the handles, which lift up to the rim like arms.

The drawing is coarse, hasty, minimal, the artist a minor one. Among the group of numerous courting cups, a cup in the Louvre (F 139), is by the same painter.

CONDITION

Broken, complete. Put together from large pieces. Some loss of the added white, on Side A, in the left eye. The added red is very faded.

TECHNIQUE

Clay Orange toned. *Potting* Bulges protrude inside at handle attachment sites. *Glaze* Glossy black. Lip, body, foot, and interior glazed on wheel. Black are lower quarter of bowl, exterior of stem, foot, and handles, and interior of foot stem save for unpainted center. Picture framed by a dark line above, three narrow lines below; narrow black line

Figure 8 Attic Black-figure eye-cup. Drawing of profile and underside

lies directly on rim. *Reserved* Foot-rim, foot bottom, insides of handles. Cup's interior is black save for a reserved medallion with two black concentric circles around center point and narrow reserved band just inside the rim. *Color: Red* Center ring in eye pupil, beard, hair of males, raised fillet. *White* On top of black, for eye balls. *Incision* Eye circles incised with compass; center hole clearly visible. Incision sets off raised fillet at top of stem.

THE GRAFFITO

Underside of foot: "S O" Read in from the rim; cut after firing. A. W. Johnston, *Trademarks on Greek Vases* (Warminster, 1979) pp. 80–83, Type 21A. This graffito was mainly used on black-figure vases.

BIBLIOGRAPHY

Unpublished

SHAPE AND EYE FOR EYE CUPS

Boardman, *Black Figure*, p. 107; Beazley, *Development, Revised* p. 62; K. Vierneisel and B Kaeser, *Kunst der Schale: Kultur des Trinkens*, (Munich, 1990) pp. 417–21; J. Jordon, *Attic Black-figured Eye-cups*, Dissertation, N.Y. University, 1988 (University Microfilms, Ann Arbor, no. 881-2638) pp. 196–202. On eyes of eyecups, also B. Cohen, *Attic Bilingual Vases and Their Painters* (N.Y., 1978) pp. 240–504.

For interpretation of eyes see, M. Eisman, "Are Eyes Apotropaic?" *AJA* 76 (1972) 210, who considers eyes decorative. See I. K. Raubitschek, *AJA* 76 (1972) 217, on eye-cup imagery, as Dionysiac. For meaning and origin of eyes, see Gloria Ferrari [Pinney] "Eye-Cup," *RA* (1986) pp. 5–20, a broader interpretation

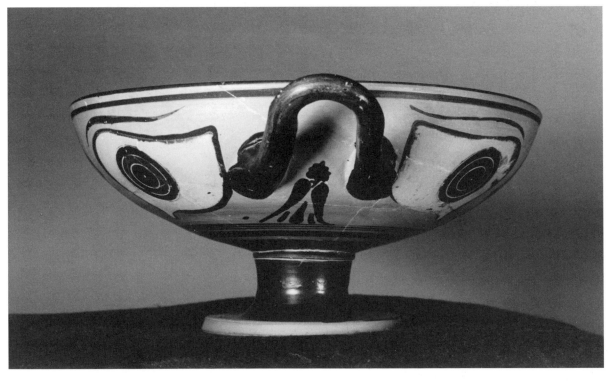

Figure 9 EA-1989-3. Attic Black-figure eye-cup. Circa 530–520 B.C. Side A/B.

ANN ASHMEAD

based on the apotropaic, Dionysiac, and also the-atrical nature of the eyes. Norbert Kunisch, "Die Augen der Augenschalen," *AntK* 33 (1990), 20–27, considers eyes as a mask of Dionysos or follower. See A. Clark, *CVA* Malibu 2 (USA25) p. 61, for fur-ther bibliography.

The painter, unnamed, repeats himself in his eye cups—physiques are very similar: stocky youth, round backed man; the youth usually keeps his forearms at same angle, more or less raised. Details may vary slightly. Many cups have three thin lines below scene. For some erotic pairs, by the same artist, in 'up and down' pose, see the following eye cups: 1) close is Louvre 139: *Para.* 82, no. 10, *CVA* Louvre 10 (France 17) pl. 105 (740) 4 and 6: similar physiques, thin forearms, shape of the eyes, and width of their rings, eyebrows, pendant flower petals with curvy-edged heart. 2) formerly Basel, present location unknown, *Para.* 82, no. 6 = *Mün-Med,* Nov. (1964), no. 67. 3) University Museum, Philadelphia, MS 2497: *Aspects of Ancient Greece: Allentown Art Museum* (Allentown, 1979), pp. 48–49, no. 21 (two hanging objects); 4) Compiègne 1095, *CVA* 1 (France 3), pl. 11 (109), nos. 16 and 18 = *Para.* 82, no. 8. 5) Reggio di Calabria, no. 1067. fragmen-tary: Georges Vallet *Rhégion et Zancle* (Paris, 1958) p. 148, pl. 11, fig. 2. 6); Geneva, Inv. MF 240, *CVA* 2[3], pl. 65 (121), nos 1–3 = *Para.* 83, no. 18: (similar hid-den hand of youth). 7) See Dunedin, New Zealand, E 59.10, *CVA* 1(1) pl. 31 (7), 5–9., Side B.

For group of courting cups, see Beazley, *Para.* pp. 82–83. For the specific "up and down" motif in courtship, see J. D. Beazley, *Some Attic Vases in the Cyprus Museum: Proceedings of the British Academy* (London, 1948) pp. 6–31. The motif was not limited however to cups: see, K. Schauenburg, "Erastes und Eromenos" *AA* 80 (1965) pp. 850–67. On origin, popu-larity, decline, of courtship scenes, see A. Shapiro, "Courtship Scenes in Attic Vase-Painting," *AJA* 85 (1981) pp. 133–43. For "Up and Down' motif in early heterosexual examples, see Shapiro (*supra*). For other erotic themes on eye cups: see phallos in place of nose Boston 08.31d: E. Vermeule, *AntK* 12 (1969) p. 14, no. 16, pl. 11, 3. For a phallos as cup base, see J. Boardman, "A Curious Eye Cup," *AA* 91 (1976) pp. 281–88. for linkage of the erotic with Dionysos, see A. Dierichs, *Erotik in der Kunst Griechenlands: Antike Welt* 19, 1987, Sondernummer [1988] pp. 20–34: "Erotik im spiegel der Gottheit: Aphrodite-Dionysos; see on male homo-sexuality, pp. 62–5: "Erotik zwischen Männern."

For *Greek homosexuality* see, K.J. Dover, *Greek Homosexuality* (London, 1978). David Halperin *One Hundred Years of Homosexuality and Other Essays on Greek Love* (N.Y., 1989) pp. 15–40, considers homosex-uality as a modern concept; in contrast, Greek ped-erasty was culturally engendered.

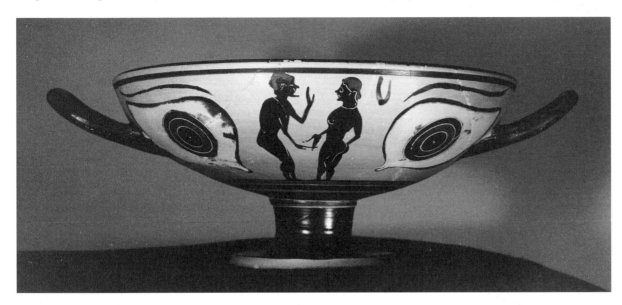

Figure 10 EA-1989-3. Attic Black-figure eye-cup. Side A.

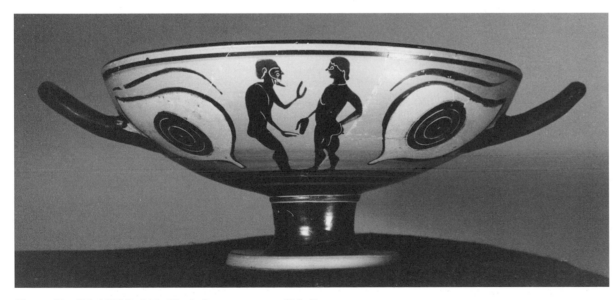

Figure 11 EA-1989-3. Attic Black-figure eye-cup. Side B.

ATTIC BLACK-FIGURE HYDRIA

Figures: 12–20
Accession number: EA-1989-1
Painter: Attributed to Near the Ready Painter by A. Ashmead.
Date: circa 540–530 B.C.
Source: Purchased from Robert Hecht ca. 1955–60.
Dimensions: H., 0.355 m.; D. of body, 0.260 m.; D. of body with handles, 0.317 m.;
 D. of mouth, 0.204 m.; D. of foot, 0.132 m.

This large hydria (from the Greek word for water, *hydor*) was designed for fetching water from the fountain, with capacious ovoid body and three handles—two horizontal handles for lifting and one vertical for pouring.

Its decoration faithfully follows the norm for hydria painting in late sixth-century Athens. In the main scene on the front is a myth popular in vase painting of the period, the recovery of Helen. On the shoulder are confronting sirens (birds with women's heads) between a pair of lions.

Five figures—a warrior flanked by two women, between two warriors—occupy the panel. The woman menaced at sword point must be Helen, she for whom the Greeks fought at Troy. Before her marriage to Menelaus, King of Sparta, Helen was abducted by Theseus and Pirithous and subsequently stolen away by Paris, Prince of Troy, instigating the ten years of war between the Greeks and Trojans. When recovered by Menelaus after the fall of Troy, he intended to kill her. According to the legend, his sword fell from his hand at sighting her beauty. Menelaus, the bearded warrior (wearing chitoniskos, cuirass and greaves, Corinthian helmet, baldric), grasps Helen's cloak by the border. Although he moves away, he looks back, pulling her by the cloak toward the Greek ships. His high-crested helmet, which is also filleted, indicates he is a person of some importance.

Helen, apparently unperturbed, stands wide eyed, gripping both mantle fold and wreath in her right hand, her left making a fist. A second woman is Helen's mirror image except her right hand is open, tilted up. Both women wear very fine peploi: Helen's has a meander hem pattern, and her cloak is embroidered both inside and out, perhaps with flowers—as indicated by dot clusters.

Two warriors—an antique Rosencrantz and Guildenstern unengaged in the action—march left, the best direction to show off their shield devices (tripod, poles and crossbeam of a chariot[?]). They wear greaves, Corinthian helmets, and carry two spears, a small bulge near the tip—an odd feature.

Various versions of Helen menaced have survived. This particular episode seems straightforward enough, and parallels an abduction of Helen on an amphora in Bloomington. Two features of the hydria scene are uncommon however—the presence of two women instead of Helen alone, and the fact that both women are bareheaded (Helen usually modestly covers her head with her mantle, a sign of marriage). If the woman threatened is really Helen, then this second woman could be Aphrodite, the goddess responsible for the reunion of Menelaus and Helen. A dress detail, not always supplied, is the train on the women's skirts. These trailing skirts may be a borrowing from the East, signifying finer dress, greater fullness of fabric, and status of the wearer.

The antithetical sirens between lions, an old-fashioned motif, occur on few hydria shoulders. In the Odyssey, two sirens were remarkable musicians; one played the lyre and another sang. They lived on an island in the Mediterranean and by their music attracted passing sailors to their rocky coast and subsequent shipwreck.

The remaining patterns are standard: rays circle the base; on the shoulder at the base of the neck is a chain of tongue pattern, alternately red and black; at the sides is a common ivy border, with few and fat leaves.

The Attic potter expressed his personality in the contours and proportions of his pots. Hydria shapes changed—the general development was from shorter and squatter forms towards taller and narrower ones. This particular shape is satisfying; although the shoulder was formed as a distinct element (emphasized by its own long, low panel of decoration—without the vertical border of ivy leaves that frames the belly panel), it is nevertheless sufficiently sloped to harmonize, rather than break with the curve of the belly. The handles tilt up ever so slightly from the horizontal. The broad rim, accented by red, has a pronounced ridge at its lip (to aid in pouring). That metalwork influenced the potter shows in the sharp angular spurs at the joins of handles and the wide lip with angular profile.

Hydriae of similar shape were decorated by the Swing Painter, Princeton Painter, Painter of Louvre F6, and the Ready Painter. This drawing style is near that of the Ready Painter judging by the generous spacing of the figures, the size, shape and number of the ivy leaves in the border, the long pointed female nose, the drapery, and the armor.

ANN ASHMEAD

CONDITION

Broken, mended from numerous pieces. Virtually complete. Restored. Missing part of helmet and crest, shield of warrior at left, part of head and cheek of Helen; part of face and hair of siren at right. Breaks repainted. A kiln depression across Menelaus at hip level may have been caused by stacking.

TECHNIQUE

Typical Attic clay. *Glaze* Glossy black. Noticeable spattering in glaze of body (in back) is evidence of brush spatter during painting. *Dilute glaze* lines marking off divisions of vase are apparent. Red discoloration, from kiln heat, at shoulder to l. of l. handle. Glazed inside neck to shoulder level. *Incision* Shields of warriors compass drawn, center holes visible. Incised line across necks of women and sirens of a necklace. Incised channel at join of neck to shoulder. *Reserved* Inside of the horizontal handles, patch on body opposite, foot bottom, underside of rim (imperfectly). *Added Color: Red* Manes, red on shoulders, ribs, hindquarters of both lions, tongue of r. lion; wing bar, tails, eye-pupils and fillets of sirens; greaves and helmets of warriors at l. and r.; dots inside ring handles of tripod shield-device; chitoniskos, helmet crest, and fillet of figure 3 (Menelaus); the women's fillets and alternate folds of their mantles; alternate tongues of shoulder pattern; two red lines inside at top of neck, two red lines along the lower edge of the panel, two lines above the rays; red line on mouth-rim and foot-rim. *White* Lions' teeth, spot above ear of l. lion, line edging belly, spots on chest of r. lion; sirens' faces, chests, dots on tail feathers, line edging red of wing bars; female flesh. Dots along all helmet crests (bigger on right warrior), shield devices, baldric (white tip, its dot-cluster pattern), and sword pommel. Drapery: dot-rosette pattern on peplos of woman at l. and on mantle (both inside and out) of Helen, and dot rows along hems and overfolds of peploi of both women. Note overlap of warrior's crest into shoulder. Rosette between two sirens.

SHAPE

Hydria: ovoid body curve; shoulder slope looks straight but is actually slightly concave. Wide mouth; lip thick, not a rounded torus. Lip has distinctive edge on underside. Neck proportionally taller than earlier but shorter than later hydriae. Lateral handles are round in cross section, tilt up slightly from horizontal. Back handle not centered between spurs on lip, nor positioned strictly plumb (slightly curved); it does not rise above rim. It was clearly formed by pulling (not rolling). Foot atypical: concave upper surface, slanted echinus edge. Underside of foot has raised center.

BIBLIOGRAPHY

Hesperia Art Bulletin 2 (1957) no. 64 (front, shoulder illustrated).

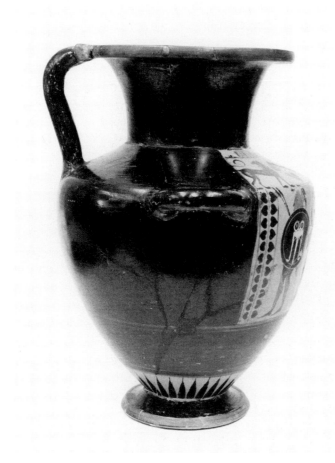

Figure 12 EA-1989-1. Attic Black-figure hydria. Circa 540–530 B.C. Right side. Attributed to Near the Ready Painter.

Figure 13 EA-1989-1. Drawing of right profile.

SHAPE

For development of Attic sixth century bl. fig. hydriae see Erika Diehl, *Die Hydria* (Mainz, 1964) pp. 57–59; Kurtz, *AWL* p. 13; and H. Bloesch, "Stout and Slender in the Late Archaic Period," *JHS* 71 (1951) pp. 35–37. Beazley, *ABV* 123, comments that the Ready Painter's hydriae look rather like modernizations of the older Lydos. Distinctive of this pot, are manner in which top of handle, lower than the rim, slopes outward, and the uncanonical foot. For discussion of comparable hydria shapes see J. Pedley, "A Black-Figure Hydria in the Fogg Art Museum," *Studies Presented to George M. A. Hanfmann* (Cambridge, 1971) pp. 121–126. For body parallel, see first, Mannheim (No. Cg 342): *MünMed* 51 (1975) no. 125 (standing near the early work of the Ready Painter) foot lost; note similar, slightly concave, shoulder line. Also compare the namepiece of Ready Ptr., Stockholm, Sweden, National Museum, Ant. 2103 (*ABV*, 129, no. 1); and Vatican no. 315, C. Albizzati, *Vasi antichi dipinti del Vaticano* (Rome) pl. 37, p. 110, fig. 51 (Ptr of Louvre F6). For 'S' curve of handle, see Toronto 919.5.142, *CVA* 1[1] pl. 24 (24) 1–2: *Addenda* 129, no. 2 (Ready Ptr). For discussion of Mannhein hydria (*supra*) and others, in relation to Swing Ptr.'s potting, see Elke Böhr, *Der Schaukelmaler* (Mainz, 1982) p. 20.

The foot Our potter chose an atypical echinus foot; compare to, but flatter than, rounder foot of Villa Giulia, inv. 5198, (unattributed) *CVA* 3[3] pl. 55 (139) no 1. For our atypical *Red-glazed lip* see Vatican no. 315, Albizzati, *op. cit.* (Ptr. of Louvre F6) pl. 37, and p. 110, fig. 51; see, also, Villa Giulia, inv. 5198, (unattributed) *CVA* 3[3] pl. 55 (139) no 1.

PAINTER

The Ready Painter was a younger colleague of Lydos. In general, *ABV* 123, 130–131 (Near the Ready painter), 686. *Para.*, 53–54; *Addenda*, p. 35. For

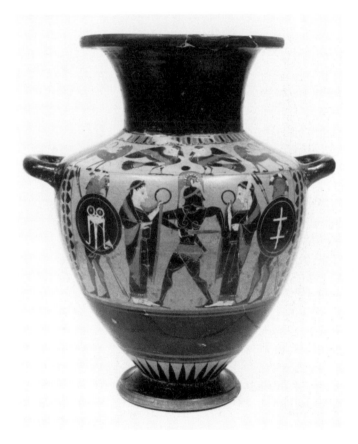

Figure 14 EA-1989-1. Attic Black-figure hydria; Near the Ready Painter. Circa 540–530 B.C. Front. Menelaus abducting Helen.

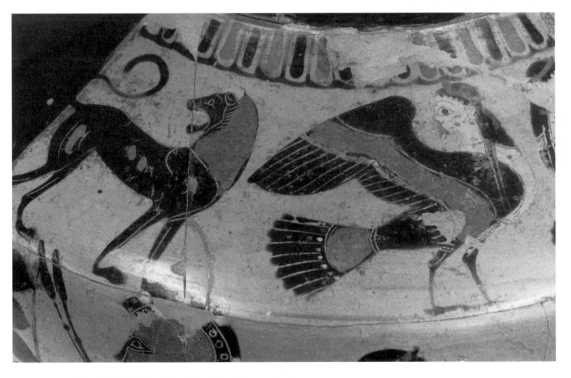

Figure 15 EA-1989-1. Shoulder. Detail of lion and siren.

attribution, the best parallel, is hydria *Mün.Med* 51 (1975) no. 125, listed as standing near the early work of the Ready Painter (now in Mannheim, No. Cg 342, according to Elke Böhr, *Der Schaukelmaler* [Mainz, 1982] p. 20, note 157) and dated ca. 535 B.C.: ivy border (from 11–12 leaves) is typical; see for style of dresses, dress tails, women's faces with long noses, large eyes. Related but less close, are: Petit Palais, 312 (*CVA* 1 [France 15] pl. 10. (Ready Painter): comparable helmet crest shape, projecting neck protector; and Toronto 919.5.142 *CVA* 1[1] pl. 24 (24) 1–2 (Ready Painter), *Addenda*, p. 35, 129, no. 2.: compare solid spear point, helmet (shape and incised decoration on crest), Although the name piece in Stockholm (*supra*) is very similar, some

details such as spear heads, knees caps, male hands, scabbard, although close, don't match. The shield blazon, pole and crossbeam, is unusual, unparalleled, as best I know, in Ready Painter. For tripod shield blazon see: Stockholm, Sweden, National Museum, Ant. 2103 and Petit Palais, 312 (*supra*).

SCENE

Sirens Only four examples of sirens on hydriae shoulders are listed by Eva Hofstetter, *Sirenen im Archaischen und Klassichen Griechenland* (Würzburg, 1990) p. 94; No. A 89 (single siren between antithetical lions) is by a related artist, Painter of Louvre F. 6.

For abduction/recovery of Helen See L Kahil, *Enlèvements et le retour d'Hélène dans les textes et les documents figurés* (Paris, 1955) pp. 99–112 and Kahil, *LIMC*, IV pt. 1, Type C., pp. 546–548. This abduction type was inspired by the Ilioupersis of Arctinos. Our hydria belongs within the subgroup: 'Menelaus seizing Helen by the himation.' The composition recalls bl. fig. amphora, Bloomington 69.108: last quarter of 6th century, *LIMC* IV, pt. 1, p. 547, no. 304, pt. 2. pl. 347, but lacks second female and Helen is veiled.

For the second woman see bl. fig. tripod base, Louvre F 151, (Kahil, *Enlèvements* p. 104, no. 105, pl. 80, 2; *LIMC* IV, pt. 1, p. 548; pt. 2, pl. 349, no. 319.) last quarter of 6th c., warrior between two mantled

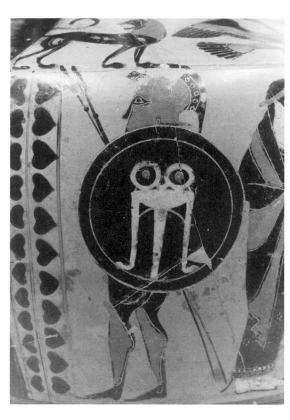

Figure 16 EA-1989-1. Detail of left side of panel.

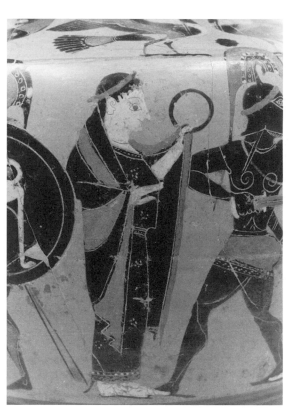

Figure 17 EA-1989-1. Detail showing second woman.

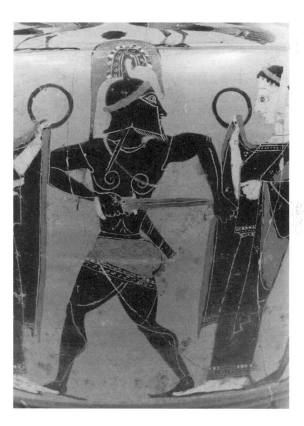

Figure 18 EA-1989-1. Detail showing Menelaus.

women, who hold wreaths; one woman is menaced by sword but not grasped.

For two women, each menaced by warrior see bl. fig. amphora, (W. Peek Collection), Kahil, *Enlèvements*, pl. 43, bis, no. 2; and (London, E 128) Kahil, *Enlèvements* pl. 44, no. 2: the second woman in each case is explained as Helen, shown twice.

For two women, one menaced and grasped, one watching, see amphora, Florence, Archaeological Museum, 76179, *LIMC* IV, pt. 1, p. 547; pt. 2, pl. 347, no. 301: women are wearing cloaks over heads.

Dress trains For some black figure representations of Helen with dress trains: see for example, trailing dress of Helen on bl. fig. amphora, Bloomington 69.108: *supra*. Also see amphora, by Taleides Painter (Private Coll), Karl Schefold, *Götter und Heldensagen der Griechen in der Spätarchaischen Kunst* (Munich, 1978) p. 189, fig. 254. We don't fully understand the language of dress according to Brunilde Ridgway (pers. comm.): see the trailing dress of dancing women, on vase from Heraeum, Samos; H. Kyrieleis, "Chios and Samos in the Archaic Period," J. Boardman and C. E. Vaphopoulou-Richardson, *Chios, A Conference at the Homereion in Chios,* 1984 (Oxford, 1986), Pl. 3. For instances of the trailing dress in sculpture, see Hera of Samos, Berlin inv. 1750 (G. Richter,

Korai (N.Y., 1968), figs. 186–9, and Artemis, Siphnian Treasury, East Pediment. P. de La Coste-Messelière *Delphes* (Paris, 1943) Pl. 91. For the long chiton of korai, see Richter (*supra*) p. 10, who quotes Sappho's reproof to a young country girl who had not been taught to gather her dress with artless grace (fragment 70).

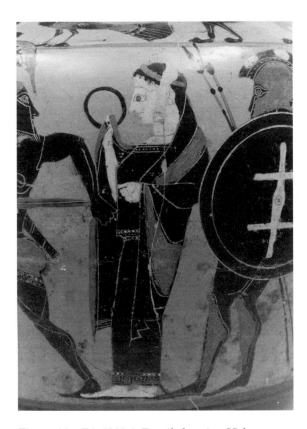

Figure 19 EA-1989-1. Detail showing Helen.

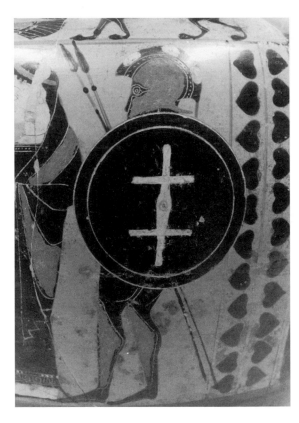

Figure 20 EA-1989-1. Detail of right side of panel.

ATTIC BLACK-FIGURE AMPHORA

Figures: 21–23
Accession Number: EA-1989-2
Painter: Attributed to the Swing Painter by A. Ashmead (Ann Steiner suggested the Swing or Princeton Painters).
Date: Late sixth century circa 530–525 B.C.
Source: Purchased in 1960s from Robert Hecht, Hesperia Art.
Dimensions: H., 0.355 m.; D. of body, 0.229 m.; D. at rim, 0.155 m.; D. of foot, 0.125 m.; W. of rim, 0.012 m.

This attractive amphora (the name means "carry on both sides") is a belly-amphora—the body and neck form a continuous curve. Amphora mouth, feet, and handles forms could differ; these round handles are old fashioned. Wine or oil could have been stored inside, or wine could have been dipped from this pot at the table.

Although both sides of this vase depict a fight over a dead warrior—a theme common on vases of the late sixth century—the panels are in no way duplicates. The front composition is more static; both fighters thrust with spears, bolt upright, stiff as the two observers. In contrast, on the reverse, one warrior leans forward, aggressively attacking his fleeing, stumbling opponent. A third warrior at the right, in backview, thrusts forward his shield, his spear aimed upwards. On the front the shields are more prominent, all frontal—they overlap, clash, lock together, as if the fallen warrior were still engaged in the battle. Both dead lie with their heads twisted toward the ground. One hand above his head, the fallen warrior on the reverse seems just moments before to have released his spear.

What the battle or who is fighting, is not clear, for attackers and defendants, are dressed alike in short tunics (but not corslets), greaves (leg armor), and Corinthian helmets. All bear round shields (the *hoplon*), the hoplite soldier's defining weapon—held by means of a metal armband and leather handhold—constructed out of a wooden frame covered by a bronze plate. There are no swords, just spears in this fray.

The artist is the Swing Painter, a very prolific, but undistinguished painter, working from about 545 to 520 B.C. He painted many combat scenes, as well as mythological scenes, and such unusual subjects as a unique stilt-dancing, a rare ball game on piggy-back, and two scenes of a maiden seated in a swing, which gave the painter his name. His preferred form was the old-fashioned belly amphora.

The Haverford panels seem to have no exact parallels, although the same cast of characters appears, shuffled about, in other fight scenes. Within the panels the artist tried not to repeat himself in details of armor and drapery, and no shield device (cross, octopus, alpha, rosette, tripod, balls) is repeated. The motif of three overlapped shields, which occurs very early in the painter's oeuvre, is clearly decorative, for realistically, since the shield with cross device is on the warrior's left arm, we should see the shield's interior, not its blazon.

Characteristic of this style are big heads, pinched, pointy noses, and clenched fists. The artist used color freely, and skillfully, as in the cloth patterns of the red bearded watcher (white rosette dress pattern, red cloak folds). Unfortunately the work is not very precise; it easily becomes careless—for instance, the hand of the left observer doesn't actually touch his spear.

Figure 21 EA-1989-2. Attic Black-figure amphora. Circa 530–525 B.C. Drawing of profile and underside.

CONDITION

Complete. Broken into numerous pieces and mended. Minor losses along the breaks and lacunae. Missing *Side A* part of helmet crest and chin of r. warrior; forehead, dress at hip-level (repainted) of r. observer; on *Side B* helmet beak of r. warrior (repainted). Minor gaps in lotus bud chain on both sides and some fractures repainted. Lost glaze areas are overpainted black. The white of shield devices is faded. Red peeling and some incrustation. Some chipping and flaking of glaze, especially on handles.

TECHNIQUE

Clay Typical Attic clay. *Glaze: Side A* Semiglossy black. Side A has many areas of skipped glaze. Red discoloration from kiln misfiring here and there. *Reserved* Edge of foot, foot bottom, and rim of mouth. *Preliminary Sketch* in dilute glaze, visible on Side A. *Dilute Glaze* Spears and staff. In many areas incomplete second application of glaze produced mottled effect: very noticeable in dress of l. observer, #1, and leg of fallen warrior, #3; especially confusing at neck of same and waist of r. warrior, #4. Artist changed plan in l. warrior, #2: originally his feet were closer together; ghost of original lower r. leg in dilute glaze visible slightly in front of r. greave. Artist marked off panel (base line is quite visible) and location of lotus band in dilute glaze.

Added *Red* All rims of frontal shields. *Side A* Drapery folds, beard of l. observer; greaves of l. warrior; helmet of dead warrior; helmet crest support of r. warrior; dress of r. observer; fillets, on all standing figures. *Side B* l. warrior: shield, fillet, chitoniskos skirt, r. greave only, blood (?) or part of shield interior tassels (?) on l. arm; both greaves of center warrior and fillet; helmet crest of fallen warrior; helmet and chitoniskos of r. warrior. Red line circles foot; red line at r. and l. sides of panels, two red lines above rays, two below panel; three on neck. *White* Shield devices, helmet crest, contours of figures (counting from left) #2, 4, 6, 7, 9; rosettes on dress of #1; shield strap of #6; dots edge skirt of center warrior, #7; dot-clusters on dress of fallen warrior, #8. *Incision* Shields compass drawn: center holes and two incised circumference circles visible. Sequence of painting visible in r. warrior, Side

B, whose foot overlaps the dilute glaze base line, and whose r. elbow overlapped by red border line.

Above panel is a lotus bud pattern edged by dilute glaze lines. Lower edge of foot and its bottom, and rim of mouth unglazed. *Interior* Glazed to depth of 0.040 m.

DIPINTO?

Problematic: On the underside of foot five strokes contrast, are light-colored, against the clay surface. Only professinal cleaning can verify whether strokes are deliberate.

SHAPE

Belly amphora. Type B with round handles (formed by pulling), flaring mouth, echinus foot.

COMPARANDA

SHAPE

For discussion of Swing Painter's amphorae, see Böhr, pp. 17–18.

PAINTER

In brief, J. Boardman *Black Figure* p. 63; J. D. Beazley, *BSA* 32 (1931–32) pp. 12–16; *ABV* 304-10, 693; *Para.* 132–35; *Addenda* 79–84. The artist's oeuvre has been collected, illustrated, and exhaustively analyzed by Elke Böhr, *Der Schaukelmaler* (Mainz, 1982). Parallels between the work of the Swing Painter and this Haverford vase are numerous.

PATTERN

The lotus bud frieze became the main ornament on belly amphorae, in second phase of the Swing Painter (Böhr, p. 26).

SCENE

Parallels for the figures abound. For the warrior fallen, supine, whose head is twisted completely around: Tarquinia, RC 7205, Böhr, no. 51 (B) pl. 53. For the l. bearded, flanking figure, watching the fight, draped in cloak (red bands, and rosettes) and holding spear, Zurich, 2466, Böhr no. 36 (B), pls. 38–39. The watching figure in long dress, at r. who holds a spear (visible beside feet), drapery (cloak?) over r. arm, looks almost like a woman, but is male since flesh is not white and holds spear.

Compare figure, Ghent University, 11, Böhr, pl. 32. for hair, dress, stance, but Ghent figure is cloaked.

Side B: Many of the cast of characters appear on an amphora in the Getty Museum, Malibu, Bareiss Collection (dated to third phase of artist), but juggled about; Böhr, no. 58, pl. 60: observers, leaping warrior, retreating warrior, even the warrior with one black and one red greave, and octopus shield device. Other individual parallels are: For the l. warrior leaping into the fray, Vatican 349, Böhr, no. 25 (B), pl. 28. The center warrior, viewed from the back, in flight collapsing onto one knee and looking back, is in an old fashioned collapsing running pose that appears in the second phase amphorae of the painter according to Böhr, p. 7: compare figure to Florence, fragment, Böhr, no. 30, pl. 32; Frankfort, Neumann, Böhr, no 44 (B), pl. 46 and Mailand, Poldi-Pezzoli 1063, Böhr, no. 56 (A), pl. 58. For warrior at r., seen from the back, who attacks l., thrusts up his shield seen in profile, see Getty, Bareiss, *supra*.

For the motif of the three overlapped shields, see Vatican G 36, Böhr, no. 1, pl. 1 (B) and an amphora from Circle of Swing Painter, Adolphseck 1, Böhr, no. U1, pl. 146 (B). Similarly styled shield devices abound in Swing Painter's work: white balls and tripod are common; for these on profile shields, see, among others, amphora, London, B 169, Böhr, no 45, pl. 47. The rosette blazon is frequent; see Japan, Priv. Coll., Böhr, pl. 51 (B). For the mannerism of a solid dab of red for shoulder drapery, l. observer, Side A, and the characteristic long toes, lotus border-pattern, see London B 169 amphora (*supra*) and Berlin, Pergamon Museum, F 1695, Böhr, 43, pl. 45.

For discussion of hoplite armor, see, A. M. Snodgrass, *Arms and Armour of the Greeks* (Ithaca, NY, 1967) pp. 48ff.

On date: the work span of the painter is very short, lasting just twenty years, ca. 540–520 B.C., according to Böhr, p. 56. The figure drawing of our amphora is not as loose as the very latest of the Swing Painter's oeuvre.

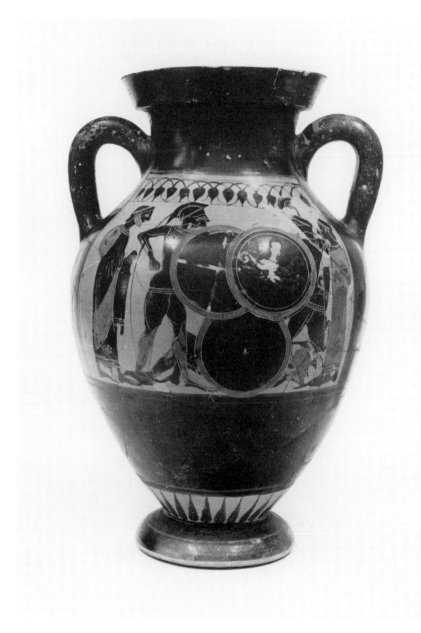

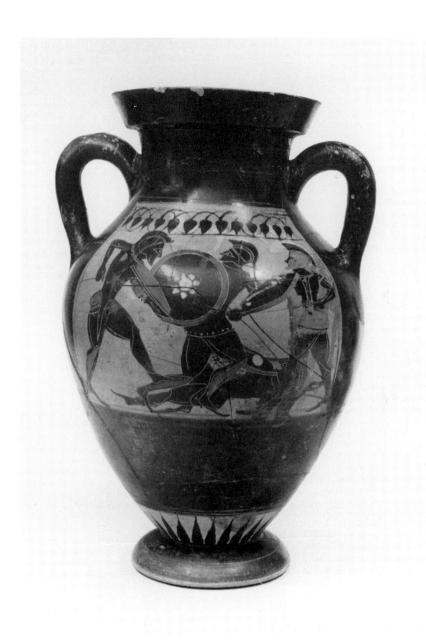

Figure 22 EA-1989-2. Attic Black-figure amphora. Circa 530–520 B.C. Side A.
 Attributed to the Swing Painter.

Figure 23 EA-1989-2. Side B.

ATTIC BLACK-FIGURE LEKYTHOS

Figures: 24–28
Accession number: EA-1989-6
Painter: Attributed to the Leagros Group by A. Ashmead.
Date: circa 515–510 B.C.
Source: Purchased from sale at Ursinus College, ca. 1965–1970.
Dimensions: H., 0.27 m.; D. of rim, 0.073 m.; D. at shoulder, 0.111 m.;
 D. of foot, 0.075 m.

Oil was essential for both life and death in ancient Athens—in trade, the home, the palestra, the sanctuary, the grave. This cylindrical vessel (lekythos) was designed to hold and pour oil—hence the narrow neck, stoppable mouth, and catch-lip.

The scene that wraps around the vase's body is rare—the earliest depiction of Hermes reclining on a ram. Here is a procession with the messenger god reclining but looking back insouciantly over his ram's head, preceded and followed by two dancing women. A third woman stands at the right greeting the god with a flower. Hermes is readily identified by his magic rod (*caduceus*), held diagonally in his right hand, his wide-brimmed traveler's hat (*petasos*) and cloak, and boots (winged only on his left foot).

Hermes behaves out of character—he does not sit like a rider sensibly upright, but rather lies like a drinker, on his side, right knee raised, and that leg crossed over the left, his elbow resting on the ram's neck, nonchalant, as if reclining on a couch at a symposium. The iconography of this scene comes directly from the world of the wine god Dionysos; for example, Dionysos is frequently depicted reclining, often on a banqueting couch but occasionally on an animal. Dionysos is attended by dancing women (maenads) wearing vine wreaths, and vines spring up where Dionysos stands. This Dionysiac linkage is even more explicit on another pot, a red-figure stamnos in the Louvre by the Berlin Painter, where Hermes reclines on a ram, while holding a huge two-handled cup (a kantharos, the drinking vessel of Dionysos); he is escorted by Dionysos' satyrs while the wine god Dionysos himself reclines on a billygoat on the reverse.

Does this ram have symbolic significance? Hermes (son of Zeus and the nymph Maia), born outdoors in a cave, was the god of flocks. Sometimes Hermes is depicted guarding sheep and goats, and often he carries a lamb on his shoulder. Hermes even gave a ram, the famous Golden Fleece, to the nymph Nephele, to save her children. But Dionysos too rides a ram or goat and this iconography is of Dionysos. We see on vases that Hermes very often stepped into the iconographic world of Dionysos in the late sixth century.

Why should this particular scene, Hermes riding in cortege, appear abruptly in the late sixth century? Is the explanation in the theater? Perhaps the vase scene was stimulated by a theatrical moment in which Hermes made an amusing entrance or joined in a drinking bout in a lost satyr-play. Only in satyr-plays could the gods be ridiculed. The City Dionysia, the most important religious event in the Athenian calendar, was the festival at which satyr-plays were performed.

Originally this lekythos was colorful, but now the white of the ram's handsome curled horn is dimmed (so too his white underbelly and genitals), and the white of the women's long fingered hands and faces is lost, leaving behind a false impression of cursory work. The crown of Hermes' hat also has lost its white; the women's dress patterns, red fillets, and wreath berries have faded. But the attention to detail and good quality of the drawing is still apparent in the incised figures, the drapery folds, the shoulder palmettes. The ram is exceptionally fine.

Who was the artist? The seven black palmettes on the shoulder are distinctive; these and the less common alternating-square pattern (billet) above the scene, the close set dots on the trailing ivy sprays, together with the shape of the vase suggest that the artist was a member of the Leagros Group.

ANN ASHMEAD

Figure 24 EA-1989-6. Attic Black-figure lekythos. Circa 515–510 B.C. Front. Attributed to the Leagros Group.

CONDITION

Broken into several large pieces. Missing: a major gap at the back, upper body, by the handle; smaller gaps occur on the front, in the forelegs and mid-body of the ram and the hair of Hermes. Added white: almost invisible. Red: very faded.

TECHNIQUE

Clay Orange toned. *Glaze* Glossy black. Glazed on wheel are lip, lower third of bowl, top of foot, and interior of mouth. *Dilute Glaze* Two pairs of lines frame billet border at top of scene to continue around body; single line lies below scene. *Reserved* Rim of mouth, neck, shoulder, foot-rim and foot's resting surface, inside of handle. *Added Color: Red* Beard of Hermes, fillets of females 1 and 3, berries on wreath of female 2. Band above tongue pattern. *White* Female flesh, crown of petasos, ram's horn, genitals, contour of underbelly. Dot pattern (larger single dots interspersed with smaller dots in foursomes for all women's dresses, their cloaks and cloak of Hermes.

SHAPE

Cylindrical lekythos with wide, conical mouth, short neck, sloping shoulder, and strap handle. Lower body curve narrows towards torus foot. Underside of foot has small, deeply recessed center.

Description: The major loss of added white, especially in the hands, justifies detailed description. Hermes wears a cloak (wrapped around his lower body, l. shoulder, over l. arm, dangling well below) that is decorated all over with a neat pattern of larger dots interspersed with tiny dots in sets of four. The fingers of his left hand are exceedingly straight; diagonal lines above his l. ankle indicate his boot. Woman at l. gestures in dancing: her once long-fingered l. hand is held vertically, palm towards Hermes; r. is held diagonally downwards, palm turned to ground. Woman at r. of Hermes steps r. but looks back, raises her r. hand over her head, its very long fingers extended parallel with ground. Her l. hand is held in front of her waist, fingers extended, palm downward. At r. a woman stands turned to l., receiving procession. She holds a flower in her r. hand (hand now looks like a fist as long white fingers are faded), her l. hand is tilted downward, fingers outstretched. Clothing pattern of all women is like Hermes' drapery; l. woman's

Figure 25 EA-1989-6. Drawing of profile.

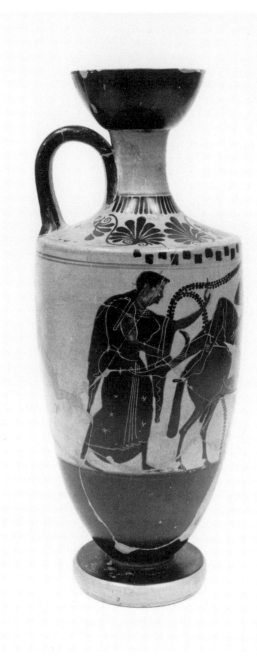

Figure 26 EA-1989-6. Right side.

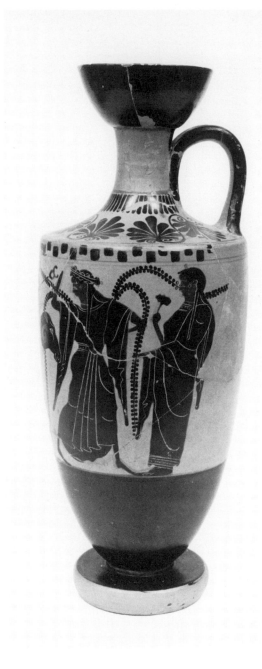

Figure 27 EA-1989-6. Left side.

dress has additional incised 'stars.' All three women wear peplos and mantle, and have long hair that falls in big locks over their backs and shoulders. Women 1 and 3 wear fillets; woman 2 wears an ivy wreath. Vine sprays spring from behind women 1 and 2.

A billet pattern of alternating squares frames the picture above.

On shoulder: where neck joins, is tongue pattern; below is palmette chain of seven palmettes (of eleven petals) linked in groups of two, three, two (the Leagran Pattern). Center and end palmettes point directly down. Dot to l. of central palmette.

BIBLIOGRAPHY

Unpublished

COMPARANDA

SHAPE

For a discussion of lekythos shape of the *Leagros Group* see: Kurtz, *AWL* p. 13, and p. 78: compare to pl. 3, 1. For list of lekythoi, see *ABV*, pp. 378–380 no's 254–294; p. 695, no. 283 bis; p. 696. *Paralipomena* pp. 163–164, 167–168.

THE PAINTER AND ORNAMENT

For general information on Leagros Group, Boardman, *Black Figure* p. 114. Compare to a member of the Leagros Group, the Daybreak Painter: Haspels, *ABL* pl. 17, 1: Athens, no. 513= *ABV* 380, no. 290: note the close packed dots on ivy strands and billet pattern (although not identical).

The Palmette Pattern on the shoulder: This type of decoration (seven palmettes, linked by tendrils in groups of two, three, two; at the neck, bars, unenclosed) is called the Leagros Group Pattern, as noted by Kurtz, *AWL* p. 13, and illustrated fig. 7b, drawing.

THE BILLET PATTERN

The billet pattern was used by the Athena and Marathon Painters (Boardman, *Black Figure* figs. 255, 256).

THE SCENE

On the seldom represented theme of Hermes riding a goat, see: P. Zanker, *Wandel der Hermesgestalt in der attischen Vasenmalerei* (Bonn, 1965) p. 50 and p. 63, note 289; for a brief recent discussion of the theme, see H. Mommsen, *CVA* Berlin, 5, [45] p. 61.

ANN ASHMEAD

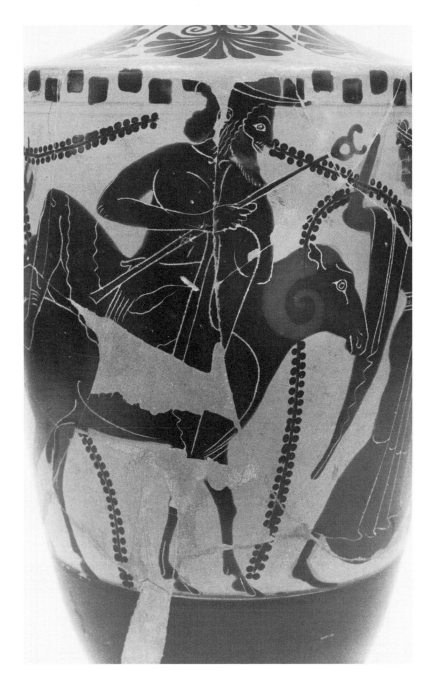

For illustrations of the Theme of Hermes Riding, Ram or Goat: see Gérard Siebert, *LIMC* vol. 5, 1, pp. 310–311, nos. 254–257, briefly listed below:

Hermes on a Ram, reclining, between flutists and male, holds drinking horn, on two skyphoi, in Rome. Bl. fig. ca. 490. *LIMC* V, 1, p. 310, no. 256, Theseus Painter.

Hermes on a Ram, reclining, between satyrs, holds kantharos, stamnos, red fig., Louvre, CA 944, Berlin Painter. *LIMC* V, 1. p. 310, no. 257. *ARV*, 207, no. 142.

Hermes on a Ram, upright, between Athena and Herakles, holds caduceus, grips horns: Lekythos, bl. fig.; NY 25.78.5, Athena Painter. ca. 500–480; *LIMC* V, 1, p. 310, no. 254.

Hermes riding a Goat, upright, holds caduceus and goat's horns, neck-amphora, Bl. fig.: Berlin F 1881, ca. 490–470. *ABV*, 478 no 2. *LIMC* V, 1, p. 310, no. 255. *CVA* Berlin, 5, [45], pl. 45. Edinburgh Painter.

Hermes more commonly Carries—rather than rides—a sheep. For examples: *LIMC* V, 1. pp. 311–314.

Some other Ram Riders: Satyr riding a Ram: Hemelrijk, *BABesch*, 49 (1974) p. 157, no. 17. Antalya A 1165, by the Gela Painter. Two maenads ride goats, on each side of a skyphos, bl. fig.: Haspels *ABL* 251, 36; Hemelrijk, *BABesch*, 49 (1974) p. 149, by the Theseus Painter.

Hermes in riding a ram behaves like Dionysos: see for example, London B 288, *CVA* 4[5]; 69 [214] no. 8a: small neck-amphora, where Dionysos rides reclining on a ram (this is not Hermes, as listed in *ABV*, 593, no. 1), by Painter of London 288.

On the topic of Hermes Entering Into The Realm of Dionysos: see P. Zanker, *Wandel der Hermesgestalt in der attischen Vasenmalerei* (Bonn, 1965) pp. 45–55. Besides behaving like Dionysos, Hermes is a guest of Dionysos, see, P. Zanker, *Ibid*, p. 50. For examples of Hermes as associate of Dionysos *LIMC* III, 1, pp. 472–3: see Dionysos who reclines on a kline, but twists around to look at Hermes, on London B 302, *ABV* 261, no. 40: bl. fig. hydria, T. Carpenter, *Dionysian Imagery in Archaic Greek Art*, (Oxford, 1986) pl. 32.

Connection with Theater: The suggestion is made, of linkage to a Satyr play, in connection with the riding Hermes on Berlin Amphora, by P. Zanker, *Ibid*, p. 37, note 154 and p. 63, note 289. and noted in *LIMC* V.1: p. 310, no. 255, *supra*.

Lezzi-Hafter, *Eretria Painter*, (Mainz, 1988) pp. 160–61 refers to a theater link (with a satyr play) for the scene of a satyr reclining on a donkey, on cup, London E 102, Eretria Painter. Although a satyr play demands the presence of satyrs and satyrs are absent from Haverford EA 1989-6, yet satyrs flank the comparable reclining riding Hermes on the Louvre stamnos, CA 944, by the Berlin painter, *supra*. It is established that entrances were made on animals: see for examples the theater terracottas, Richmond Museum of Art, which show figures riding large cocks. Richard Green, however is hesitant to posit a connection with the theater because of the presence of maenads on Haverford EA-1989-6. Of the latter scene he writes (pers. comm. Nov. 1992), "Inspired by theatre may be more likely than representing theatre."

Figure 28 EA-1989-6. Detail of Hermes on a ram.

ATTIC BLACK-FIGURE OLPE

Figures: 29–32
Accession number: EA-1989-8
Painter: By Painter of Conservatori 87.
Date: 520–500 B.C.
Source: Purchased from Robert Hecht, *Hesperia Art.*
Dimensions: H., 0.215 m. to rim (not spurs); D. of mouth, 0.099 m.;
 D. of body, 0.314 m.; D. of base, 0.069 m.

Archaeologists assign the name *olpe* to this jug of practical shape with low center of gravity whose sides are formed in a continuous S curve. One of the main functions of the olpe was for the decanting of wine and ladling it from a larger container to a cup. Olpai form a small heterogeneous group of jugs which stand apart from the main-stream oinochai (wine pitchers) of the late sixth century, both in profile and in decoration.

This handsome example, like most olpai, bears its scene in a panel on the front (as opposed to a less common sub-group in which the scene is wrapped around the body). Its idiosyncratic combination of shape and patterns are rare within its group; unlike decorated olpai this vase is footless and its wide neck is painted with two pattern-bands, rare on olpai with a glazed mouth, where one band is usual.

On our olpe, Peleus (his name is inscribed) is shown treed by a lion and boar. The future father of Achilles squats precariously, balancing his feet on separate branches, gripping a thin branch in his left hand. His right is clenched but empty. He wears a short cloak wrapped around his hips, and a baldric in white over his right shoulder and his scabbard (empty?) projects behind him. A red fillet compresses his abundant curly hair; his beard is red. Short of space, Peleus overlaps the border and the beasts are superimposed. The animals are picked out in white and red: a magnificent white tusk and underbelly for the boar, dense red mane spots and a threatening red-ringed mouth and white teeth for the lion. An artistic feathered hair pattern decorates the lion's spine. The side ivy-patterns are canonical.

This rare scene of Peleus taking refuge in a tree is known on only two other vases, a black-figure oinochoe in the Metropolitan Museum, New York, and an amphora in the Villa Giulia Museum, Rome; both repeat the pattern of Peleus crouching to right, holding a branch, while below a boar turned right confronts a lion to left. Since this setting by itself—confronting lion and boar under a tree—

occurs on another olpe, but sans Peleus, perhaps one source, now lost, inspired all these scenes.

This odd episode occurred after Peleus visited Akastos in Iolkos. While he was there the wife of Akastos, Astydamia, fell in love with him. She tried to seduce Peleus, but when Peleus rejected her advances, she denounced him to Akastos and falsely accused Peleus of trying to rape her. Akastos believed the story, but not daring to kill his guest, he lured Peleus to Mt. Pelion and abandoned him there, weaponless, so that he might fall a prey to the wild beasts. The gods, however, took pity on the virtuous Peleus and sent the wise centaur Chiron to him with a divine knife made by Hephaistos, with which he killed the beasts. In an alternate account, after hunting, Peleus fell asleep in the evening and Akastos abandoned him having first hidden his magic sword in a dung heap. According to this second version of the myth, the unarmed Peleus was almost put to death by wild centaurs who lived on the mountain, but Chiron rescued him and gave him back his sword. Since there are wild mountain beasts on this vase as Peleus' assailants, not centaurs, our scene illustrates the first version of the myth. On this olpe Peleus does not hold a knife—although it could be in his scabbard.

This fine painter, attentive to detail, is unknown. Patterns are revelatory; those on the neck are neatly drawn straight upright and well spaced, and the triple net pattern beneath an upright lotus band is an uncommon olpe decoration. This pattern combination links our olpe to another in Rome (Conservatori Museum) decorated with Herakles wrestling Triton; the painters must be one and the same. The same artist painted a third olpe in St. Petersburg (The Hermitage), again with Herakles wrestling Triton.

The shape and style of the vase suggest a date between 520–500 B.C. The shape seems later, the drawing earlier, in the period.

ANN ASHMEAD

CONDITION

Broken. Missing are segments of the lower panel, hind quarter of boar and lion. The handle is slightly chipped near its base. The body has been repainted.

TECHNIQUE

Clay Fine Orange-red. *Glaze* Glossy black. Glaze on lower body l. side has fired red. Interior of mouth and neck were glazed, to shoulder level (a depth of 5.3 cm). *Reserved* panel on front; underside of foot. *Added Color: Red* Peleus' fillet, beard, l. nipple, scabbard, and alternate folds of Peleus' cloak; boar's muzzle and tongue, and dense dots on his neck (these overlap white, so added last); base of lion's tongue(?). Double lines below the panel continue around vase. Red line on inner edge of mouth. *White* Baldric, lion's teeth, snout (faded), boar tusk and underbelly, splash behind ear, on shoulder (faded), on rump (faded) and hind legs.

Two glazed lines above and below lotus pattern, and below triple net pattern. One glazed line for ground line. Side ivy pattern framed by double lines.

BIBLIOGRAPHY

Hesperia Art Bulletin XXII no. 6: note that the full photograph is reversed, but not the detail. A. Clark, *CVA* Getty Museum, Malibu 2 (25) cites Haverford olpe, when in Paris Market, on pp. 7 and 10.

Figure 29 EA-1989-8. Attic Black-figure olpe. 520–500 B.C. Right side.

Figure 30 EA-1989-8. Front.

COMPARANDA

GRAFFITO

"X" Placed in center of bottom; cut after firing. This graffito is common and long-lived. A.W. Johnston, *Trademarks on Greek Vases* (Warminster, 1979) pp. 120–122 and 207= Type 8D.

SHAPE

Rare. A footless olpe with continuous curve, round mouth, echinoid lip, set off from neck by a groove. Spur-like projections at either side where handle attached to mouth. A low strap handle, concave on the outer face, that rises slightly above the rim. Wide neck. The greatest girth of this jug is at midbody (rather than in the lower body). The bottom is slightly concave. The body shape is that of a bail-handled vase by the Sappho Painter, Lausanne, Gillet Collection, Boardman, *ABFV* fig. 266; J. Boardman and D. Kurtz, *Greek Burial Customs* (Ithaca, NY, 1971) figs. 37–38.

In general, on oinochoai, see M.G. Kanowski, *Containers of Classical Greece, A Handbook of Shapes* (St. Lucia, 1984) pp. 109–111. On oinochoai, in detail, see J. R. Green, "Oinochoe," pp. 1–16, especially p. 7, *BICS* (*Bulletin of the Institute of Classical Studies: University of London,* 19 [1972]). Our example is Beazley Shape 5a (type with lower handle).

For footless olpai, compare to black glazed examples from the Agora, B. Sparkes and L. Talcott, *Agora* 12: *Black and Plain Pottery* (1970), pl. 13, nos. 264–266, ca. 500 B.C.; in these red lines are placed at the greatest circumference. Compare body contour and mouth to olpe, Hermitage no. 1450 (*infra*).

For glazed mouth (unpatterned): Note that a round mouth with a glazed lip of echinus profile with 'spurs' (projections where the handle attaches to the mouth) is a profile better known decorated with checkerboard or ivy pattern. For olpai with glazed echinus lip see, Hermitage, no. 1450 (St. 38): K. Gorbunova, *Chernofigurnye atticheskie vazy v'Ermitazhe* (Leningrad, 1983) pp. 99–101, no. 71, illustrated p. 101, and at front, in color; has 'spurs' on lip. See also Rome, Villa Guilia, M. 548: P Mingazzini, *Vasi della Collezione Castellani*, (Rome, 1930), pl. 85, 2 (no 'spurs' on lip).

Patterns on Neck: Necks painted with two pattern-bands are rare on olpai with a glazed mouth, where one band is usual. Compare for neatness, style, patterns, with following two olpai: closest, in respect to double neck pattern is, Rome, Conservatori Museum 87: *CVA Museo Capitolino* (Italy 36) pl. 29, (1629) 1= Gudrun Ahlberg-Cornell, *Herakles and the Sea Monster in Attic Black-Figure Vase-Painting* (Stockholm, 1984) p. 64, no. 7 (unattributed), illustrated p. 145, fig. X7: upright lotus above a triple net pattern; in panel, Herakles wrestling Triton; compare Triton's nipples (incised circles) to those of Peleus.

Compare for the upright lotus chain on neck (but no triple net pattern): Hermitage, no. 1450: (*supra*): Herakles wrestling Triton. Same painter as Conservatori 87 (*supra*). Perhaps our painter's choice of triple net pattern with dark mouth was influenced by patterns on oinochoe decorated with tall panels, such as Würzburg, 340: E. Langlotz, *Griechische Vasen in Würzburg*, (Munich, 1932), pl. 103.

For delicacy, size of letters, shape of omicron, compare esp. Leningrad, no. 1450 (*supra*).

For Motif of Peleus Up a Tree:
1. New York, Metropolitan Museum of Art, 46.11.7 *MMA Bulletin* 6 (1947) pp. 255–260: white ground, dated ca. 520 B.C., Painter of London B 620. Peleus is minuscule compared to boar; tree branches sweep up; a boar turned to r. confronts a lion to l. (animals do not overlap). By Painter of London B 620 *ABV* 434, no. 3.
2. Villa Giulia 24247: bl. fig. amphora *CVA* Villa Giulia 1 (1) pl. 9 (13) nos. 3–5. Side A. Peleus treed, holds a knife; below a congress of wild beasts (a boar turned r., two deer, wolf, lion forepaws up, as if waving, turned l.). Side B. The centaur Chiron arriving.

For crouched pose of Peleus, compare to Heracles squatting on a rock, roasting meat (Sappho Painter), New York, Metropolitan Museum of Art 41.162.34, *ABV* 507, 5; *LIMC*, 2, pt. 2, pl. 670, Astra 3.

For the scene, but without Peleus, see following: bl. fig. chous, once Philadelphia Market, *Hesperia Art* 44, no. A 4; late Japanese Market, *Cat. Sotheby at Mitsukoshi* (Tokyo), 1–2, Oct. 1969, no. 79. (ref. kindness of Andrew Clark), lion to right facing a boar to left, white apple tree between. Oinochoe, once Gela, Russo-Perez, *Paralipomena* 265. Lion and boar with tree between: may belong to Class IV of oinochai by the Athena Painter or from his workshop (workshop according to Andrew Clark). White ground oinochoe, Palermo, Athena Painter: lion turned to r., tree, boar to l. (ref. from Jenifer Neils). Perhaps these last two onochai are the same. The lion and boar recur as sacred animals in many mythological exploits: see John Pinsent, *Greek Mythology* (NY, 1991), p. 117.

For myth: Marjorie J. Milne, "Peleus and Akastos" *MMA Bulletin* 6 (1947) pp. 255–260, recounts

Figure 31 EA-1989-8. Detail of Hermes up a tree.

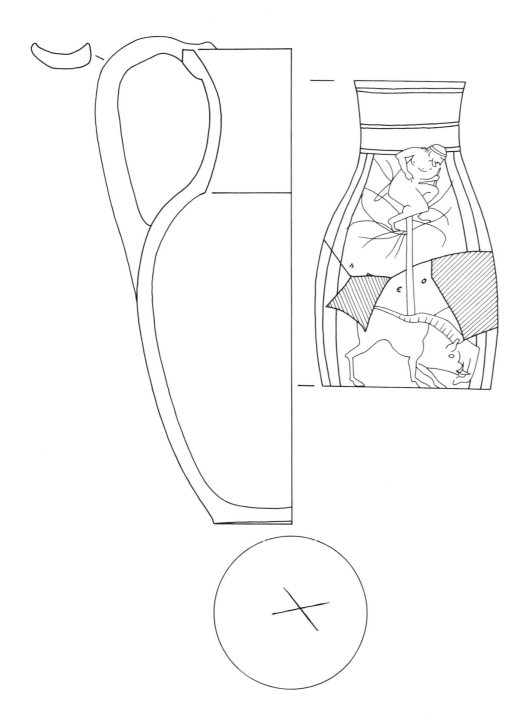

differing versions of myth, with classical sources: Aristophanes, *The Clouds*, 1063, Apollodoros Library III.13.3 et al. Ovid *Metamorphoses* XI 221, ff.

Figure 32 EA-1989-8. Drawing of profile and underside.

ATTIC BLACK-FIGURE NECK AMPHORA

Figures: 33–36
Accession number: EA-1989-7
Painter: Leagros Group: Attributed to the Group of Würzburg 210 by A. Ashmead.
Date: Circa 500 B.C.
Source: Purchased from Robert Hecht, Hesperia Art.
Dimensions: H., 0.314 m.; D. of body, 0.193 m.; D. of rim, 0.145 m.; D. of foot, 0.119 m.; W. of rim, 0.010 m.

In certain periods of Athenian vase painting subsidiary neck, shoulder, sub handle, and body ornaments are so faithfully wedded to a pot shape that the ornament becomes exactly predictable. Thus this neck-amphora (characterized by a neck off set from the body in contrast to the continuous neck-body curve of the belly-amphora), with its triple reed handles and small raised fillet at base of neck, is coupled to standard florals (palmette and lotus bud chain on neck; tongue pattern on shoulder; lotus buds linked to four palmettes on sides; rays and lotus bud chain on base).

The belly's scene spreads free, not confined inside panels. We see a mythological revel of maenads and satyrs, followers of the God Dionysos, a very popular theme in late sixth century vase painting. Although Dionysos is absent, the spreading vines behind the center maenads hint at the God, who was frequently depicted holding spreading vines while flanked by maenads and satyrs. On one side we see a maenad clacking castanets between two satyrs; on the reverse are three more castanet-playing maenads. These revelers, judging by their feet and body positions, may be dancing in a circle. The satyrs' nudity contrasts with the fully dressed maenads, who even wear necklaces and earrings, and one wears the maenad's attribute, a leopard skin. All the maenads have small black beady eyes, which would have been startling against their white faces. The satyrs have long torsos, heavy thighs, bushy beards, and long horse ears. The figure drawing style places this pot within the Leagros Group.

The Leagros Group is the last great group of Attic black-figure vases. Although not equal to the best contemporary red-figure, the vases have great vigor. The group is dated ca. 520–500 B.C., after the invention of the red-figured technique. There are about 400 vases in the group, nearly half of which, like this one, are neck-amphorae, and the majority of the rest are hydriae. The group's name, Leagros, comes from the kalos (love) name found on some hydriae. Charac-teristics of the group are as on the Haverford vase: pronounced incision, the moderate display of anatomical detail, restrained use of added color in the drapery folds and patterns, and tiny eyes.

On the underside of the foot, incised after firing, are the Greek letters *lambda* joined to *epsilon* (λε). Two other Haverford College vases (nos. EA-1989-3 and EA-1989-8) have letters inscribed under their feet. These graffiti are trademarks made by the potters or dealers. Their interpretation is complex. They are usually found on Attic pottery in the late sixth and the fifth centuries and may vary from single letters and non-alphabetic signs to two-letter abbreviations and monograms or ligatures. They probably refer to pot-batch numbers, vase names, or prices. The majority of vases inscribed with trademarks have been found away from their place of manufacture. This graffito on the foot, *lambda* joined to an *epsilon,* is found on other vases of the Leagros Group.

ANN ASHMEAD

CONDITION

Mended from numerous pieces. Breaks repainted. Breaks across head r. satyr, Side A. B/A handle (left handle, viewed from front) chipped. Glaze flaking off handles and maenads' skirts on Side B. White flesh very faded.

Figure 33 EA-1989-7. Attic Black-figure neck amphora. Circa 500 B.C. Side A. Attributed to the Group of Würzburg 210.

TECHNIQUE

Clay Typical Attic clay. *Glaze* Glossy black. Noticeable red discoloration, from kiln heat, on foot and rays above. *Added Color: Red* Drapery patterns, belt of central maenad (Side B), head bands of all maenads, dot on l. satyr's hair; band at top and bottom of amphora body. *White* Female flesh, drapery patterns, leopard-skin spots. Sequence of painting shows that base line was laid first, then figures (their feet overlap the ground line), then sub-handle palmette (which overlaps the satyr's foot). *Incision* Incised channel above neck pattern, two where body joins foot.

GRAFFITO

On underside of foot, incised after firing. Ligature of *lambda* and *epsilon*: epsilon stands vertical to foot edge and has a projecting middle bar; lowest bar is not one with stroke of *lambda*. Compare, A.W. Johnston, *Trademarks on Greek Vases* (Warminster, 1979) p. 146, Type 21E, vi., no. 50, fig. 10, aa. Johnston (*Trademarks,* p. 218) discusses the various letter shapes. See Brian A. Sparkes, *Greek Pottery: An Introduction* (Manchester, 1991) pp. 124–131 for concise explication of graffiti, dipinti, trademarks.

SHAPE

Standard neck amphora: echinus lip, triple ribbed handle, torus. Narrow raised fillet at juncture of neck and body; ring between body and foot. Raised nipple in center of base.

DESCRIPTION

The loss of added color, especially in hands, justifies a more detailed description. *Side A* The maenad who dances to the l. but looks back, clacks castanets in her raised l. hand, while holding her r. hand horizontally, palm down, before her chest. The l. satyr, seen in profile dancing towards her, has his l. hand raised, palm forward; it is considerably larger than his r. fist. He sports a dab of red color in his forehead hair. The other satyr who leaps r., while looking back, clenches both hands in front of his body. An "+" indicates his chest divisions. His face is damaged by scratches and breaks. Both satyrs are naked, have full beards, long goat ears, and wavy tails. *Side B* The flanking maenads who

dance r.; all look behind themselves. The center maenad is identical to the maenad of Side A, except for her red neckline and belt. The l. maenad holds a faded white wreath [?] in front of her chest. The r. maenad, unlike her sisters, raises her castanet in the r. hand—her l. is held horizontally in front of her

Figure 34 EA-1989-7. Side B.

chest—and wears a leopard skin, cinched about her waist and over her l. shoulder, its spotted leg dangling between her legs. All the maenads wear their hair bound up in a red fillet; all wear long chitons (dresses), pulled up in a *kolpos* fold over the skirt, at the waist, and cloaks draped over both shoulders; dresses and cloaks are both patterned with red dots and tiny white dots (in triplets, now faded). All maenads wear necklaces, and earrings are visible on the maenads on Side B. Their eye pupils are a tiny black dot. Note that tiny buds, dots, and circles are accent marks in the center of the sub-handle palmettes. Glazed: exterior of mouth, handles and foot and inside to shoulder level. *Reserved* Lip, underside of foot and foot-rim.

BIBIOGRAPHY

Unpublished

COMPARANDA

THE PAINTER AND ORNAMENT

Numerous neck amphorae display this particular coupling of floral patterns on neck and body: a sub-group of them, like this one, has a raised fillet at the top of the body: Group B,b: 208–217, E. Langlotz, *Griechische Vasen in Würzburg* (Munich, 1932) pp. 37–39. Within this sub-group compare the following three neck amphorae for similarly drawn ornament, as well as bacchic themes. Stylistically closest is Würzburg 210, attributed to the Leagros Group, (*ABV* 373, no. 178; Langlotz, *op. cit.*, pl. 52): Side A, Dionysos between dancing satyrs, shares with the Haverford amphora, besides subsidiary ornament, the close, small dots on the vine leaves, the pose of the high stepping satyr, and details such as satyr's fore-head hair tuft, style of incised kneecaps, and leg muscles, among others. Compare also Brooklyn 62.147.2: *Aspects of Ancient Greece: Allentown Art Museum September 16 through December 30, 1979* (Allentown, Pa., 1979) pp. 50–51, no. 22, attributed to the Leagros Group; Side B: compare patterns and composition of maenad between two satyrs. Compare Vatican neck-amphora, 390: C. Albizzati, *Due nuovi acquisti del Museo Gregoriano-Etrusco* (Rome, 1929) p. 9, fig 3. = Albizzati, *Vasi antichi dipinti del Vaticano* (Rome, 1925–39) figs. 113–115: Side B. Dionysos between two dancing satyrs and maenad. On the Leagros Group see, Beazley, *Development, Revised* pp. 74–80, and Boardman, *Black Figure* p. 110.

THE SCENE

For companions of Dionysos: see Thomas H. Carpenter, *Dionysian Imagery in Archaic Greek Art: Its Development in Black-Figure Vase Painting* (Oxford, 1986) pp. 76–97 and Guy Hedreen, *Silens in Attic Black-figure Vase-painting: Myth and Performance* (Ann Arbor, 1992). For dancing gestures of satyrs, one hand in a fist, one raised and open: see,

among others Würzburg 210; Brooklyn 62.147.2. For both hands clenched before chest, see Brooklyn 62.147.2. For high stepping pose: Würzburg 210 and Vatican 390 (all *supra*).

For the early Greek round dance: see Renate Tölle-Kastenbein, *Frühgriechische Reigentanze* (Waldensee/Bayern, 1964) pp. 54 ff.

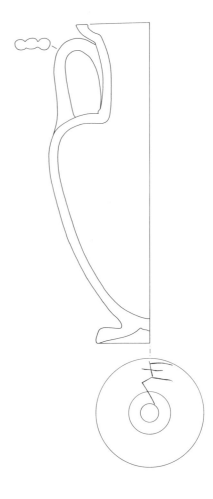

Figure 35 EΛ 1989-7. Side B/A.

Figure 36 EΛ-1989-7. Drawing of profile and underside.

ANN ASHMEAD

ATTIC BLACK-FIGURE SKYPHOS

Figures: 37–40
Accession Number: EA-1989-4
Painter: Attributed to the Theseus Painter by R. Hecht.
Date: Circa 500 B.C.
Source: Purchased from Robert Hecht
Dimensions: H., 0.181 m.; D. of rim, 0.221 m.; D. with handles, 0.294 m.;
 D. of foot, 0.141 m.; D. at stacking ring, ca. 0.179 m.

This imposing shape, with deep bowl and a broad, serviceable, steady foot, was a popular drinking cup of the so-called Heron Class (named from the white heron frequently placed at the handles). The drawing is pleasing and curvaceous—the men have distinctive stocky bodies, and round heads, with small mouths and jutting chins. The artist, the Theseus Painter (named after his favorite subject, the Deeds of Theseus) was the chief artist of the major skyphos workshop of the period.

The subject merits a detailed description. On each side of the bowl we see teams of *ephedrismos* players: six naked males in all, two pairs alternating with two single figures, all moving right. In each pair, the artist distinguishes between the bearers (hefty, pot-bellied, large-headed men, with short hair fringe at neck) and the slighter youths whom they carry piggy-back. The mounted youths hang on by squeezing their knees together, and by clasping their hands across the men's chests (except for the left youth on Side A, who seems to grip the right elbow of his bearer). The bearers grip the youths' shins, and lean forward for balance. The lead man on each side carries a white club, horizontally; the other single figure was probably empty handed, judging by similar scenes. The lead on Side A, at the right, looks ahead, but on Side B he looks back, linking the two groups. All the players wear red fillets. On the ground at the right on Side A is a dumbbell shaped target (a stone), set in a low conical white mound of sand (?). Below the handles, vines sprout from entwined stalks and fill in the spaces, suggesting an outdoor setting.

The game has been identified as child's game called *ephedrismos*, a kind of blind man's bluff. This vase is one of its very earliest representations, but a problem arises in matching the illustrated action to ancient descriptions of *ephedrismos*.

The ancient literature describes the game thus: "They put down a stone and throw at it from a distance with balls or pebbles. The one who fails to overturn the stone carries the other, having his eyes blindfolded by the rider, until, if he does not go astray, he reaches the stone, which is called 'dioros'" (Pollux :IX, 119). A variant of the game was called 'en kotyle' (in a cup), where the loser (eyes still covered) locked his arms behind his back to form a cradle (a cup) in which the winner placed his knee and was then carried (Pollux :IX, 122).

The Theseus Painter persistently on skyphoi illustrates a version of the game that differs from Pollux's description. For example he shows teams of players (six or twelve, not just two participants). The bearer (loser?) sees where he is going (he is not blindfolded). The bearer grips his rider by the shins (not the knee) and the leaders carry clubs, which seem to be integral to the play, either to hit the ball or stone to the target, or perhaps to control the players. Furthermore the teams are formed of heavier versus slighter players; they seem to form a line.

It is possible that this event has an erotic connotation, because of the mix of men with youths. Or we may see some event connected with a festival or the theatre (twelve players, as in a chorus).

The game of *ephedrismos* persisted in popularity: there are representations in the Archaic, Classical, and Hellenistic periods—marble statues, vases, terracottas, and gems.

CONDITION

Broken, incomplete. Missing: *Side A* Upper half of figures 1 and 2 (*ephedrismos* pair), and upper half of 3 (single male), plus rim above. *Side B* Lower half of figure 8 (bearer); all of figure 9 (single male) except head, l. leg and r. foot. Slight flaking of glaze inside.

TECHNIQUE

Clay Attic, fine, orange-brown color. *Potting* Handles pulled. *Kiln* Stacking ring visible at level of lead figure's l. hand, Side A. *Glaze:* Glossy. *Reserved* Underside and the foot resting surface. *Dilute Glaze* Narrow bands subdivide the picture field: a line above the picture; three fine lines above and two below the vertical stokes around the foot. *Added Color: Red* Fillets worn by all figures.

White Clubs, "fruits" on vines, mounds of earth. Alternate vertical strokes around base (much faded).

Figures stand on two thickly glazed ground lines. At base of bowl is a band of alternating black and white strokes, between narrow bands. At rim is a border of ivy leaves. Inside glazed, with a dilute-glazed circle in a reserved center. In center underside are two concentric circles with central dot; inner face of foot-ring glazed.

SHAPE

Skyphos: large, deep bowl, thick walled, everted rim. The handles (round in section) are set well below the rim, and tilt to rise above the rim. Torus ring foot. Torus fillet between bowl and foot.

BIBLIOGRAPHY

Unpublished

COMPARANDA

THE THESEUS PAINTER:

In general: Boardman, *Black Figure*, p. 147. For other bl. fig. skyphoi, depicting ephedrismos, by the painter:

1. Incomplete skyphos in Copenhagen: National Museum: IN 6571, *CVA* Denmark 3 [3] pl 11, [121] pl. 119, 9a–b.

2. Athens, Agora Museum P 1546, M. Moore, *Agora 23: Attic Black-figured Pottery (1986)* no. 1490; *Hesperia* 15, 1946, p. 29, pl. 41; Beazley *ABV*, p. 518, no. 54.

3. P 23174, fr.: M. Moore. *Agora 23: Attic Black-figured Pottery (1986)* no. 1491; Beazley *ABV*, p. 704, no. 27 bis.

4. Very close is an unattributed fragmentary skyphos in the Hague (inv. 2178, Scheurleer, CVA

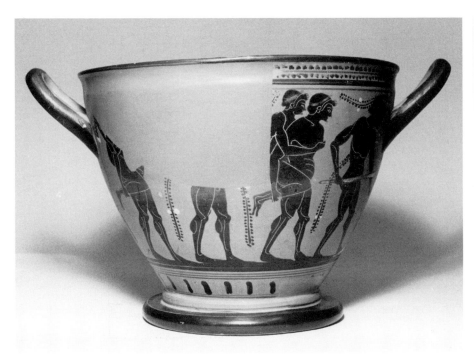 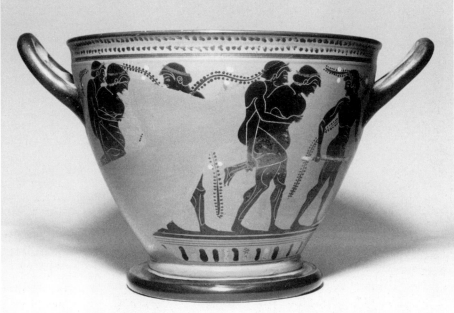

Figure 37 EA-1989-4. Attic Black-figure skyphos. Circa 500 B.C. Side A. Ephedrismos Figure 38 EA-1989-4. Side B.
Players. Attributed to the Theseus Painter.

2(2) pl. 6 (75) 5–9. Not in Beazley's *ABV, Para.* or *Addenda.*)

5. Herry Collection, Anvers, bl. fig. skyphos. Reference from Copenhagen *CVA* Denmark 3 [3] p. 97. For further discussion of these skyphoi see: F. Brommer "Huckepack," *J. Paul Getty Museum Journal,* vol. 6–7 (1978–79) p. 142, and note 9.

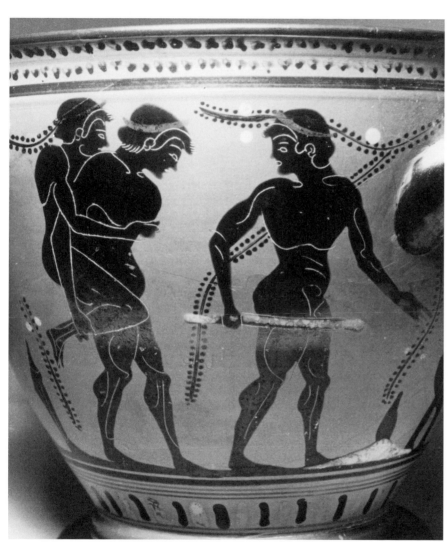

Figure 39 EA-1989-4. Side A. Right side of panel with handle, lead youth and target.

THE SCENE: THE GAME

For ancient references to the game of *ephedrismos:* Pollux, (Onomasticon, IX, 119, 122 (en kotyle). Hesychius, *Lexicon* ephedrizein. Athenaeus, XI, 479a. Eustathius, on Iliad, V and 306. XXII, 494. S. Stucchi, *EAA* III (1960) 356–357.

For Bibliography: Most recently, on the game: F. Brommer, "Huckepack," *J. Paul Getty Museum Journal,* 6–7 (1978–79) pp. 139–146, who publishes a lekythos of satyr carrying a woman, lists various scholarly points of view, distinguishes games (team or pair), piggy back holds, and players (males, females satyrs, erotes). Maria Reho-Bumbalova discusses game's erotic symbolism, "Eros e il gioco dell'ephedrismos su una lekythos di Sofia," *BABesch* 56 (1981) pp. 153–8, figs. 1–8, publishes a red figure Kertch lekythos, showing a woman carrying an Eros. F. Eckstein, "Ephedrismos Gruppe im Konservatoren Palast," *Antike Plastik* VI (1967) p. 78, note 24 discusses the game. See also A. Ashmead and K.M. Phillips, *Catalogue of the Classical Vases: Rhode Island School of Design* (Providence 1976) no, 59, on Apulian skyphos, a woman carries Eros; further references to representations.

The team game illustrated on EA-1989-4 bears some similarity to a piggyback ball game in which a team of men grouped in a line carry youths seated on their shoulders. For team ballgame examples, see: London Amphora B 182, by the Swing Painter; Böhr, pl. 197, a., and Oxford,

lekythos, 1890.27 by the Edinburgh Ptr., (*Paralipomena* 217, no. 2) Böhr, pl. 197,b. and p. 49.

Ephedrismos as a Childs Game: On this topic see Frederick A.G. Beck, *Album of Greek Education* (Sydney, 1975) p. 53 and pl. 65, no's. 332–336; and P. Zazoff, "Ein altgriechisches Spiel," *Antike und Abendland*, 11, 1962, 35–42; and K. Schauenberg, "Erotenspiel" *Antike Welt* 7, (1976) Heft. 3, 41; and M. Reho-Bumbalova, *BABesch* 56 (1981) pp. 154, note 11 for further citations.

Epedrismos and the Theatre: See M. Reho-Bumbalova, *BABesch* 56 (1981) pp. 154, note 21: a Comedy of Philemon, had once the name of *Ephedrismos* or *Ephedritai.* She refers to C. Robert, "Kinderspiele," *AZ* 1897, 80.

Figure 40 EA-1989-4. Drawing of profile.

ATTIC WHITE GROUND LEKYTHOS

Plates: 41–46
Accession number: EA-1989-9
Painter: Attributed to the Painter of Munich 2335 by A. Ashmead.
Date: ca. 440–420 B.C.
Source: Purchased from the Estate of Samuel Chew, 1960.
Dimensions: H., 0.293 m.; D. of rim, 0.052 m.; D. of shoulder, 0.090 m.;
 D. of foot, 0.062 m.; Resting surface of foot, 0.053 m.

Oil was an important and costly liquid used, among other purposes, for the preparation of the corpse for burial and as a grave gift. In the group of oil vessels, white ground lekythoi have a special place—in the Classical period they were made almost solely for the cult of the dead and their iconography reflects this funerary purpose. Their impermanent white technique, less stable than the black glaze, was too fugitive for daily use, but was appropriate for burial or dedication after burial at the grave side. White ground lekythoi were in great favor in Athens from the second quarter of the fifth century to its end. Most have been found in graves.

This shape is that of a normal Attic lekythos developed at the end of the sixth century. Part of the decorative schema of this lekythos remains linked to black-figure—the black glazed neck, handle, and lower body, and the matte black meander band on the upper body. But the shoulder palmettes are no longer black, but matte red. (Green and blue was applied after firing on later lekythoi.) The white surface is a suitable ground for polychrome decoration; the color palette is restrained. The woman and man are outlined in fine lines of matte red. The shoulder palmettes, hair, and man's cloak are a similar matte red. The grave ribbons, the woman's lips, and her chiton folds are a deeper blood red. The man's spears are in matte ochre yellow, while thin glossy (actually dilute glaze) brown-yellow lines circle the vase above and below the scene. Following custom the woman's flesh was once painted white. This polychrome painting is the technique that brings us closest to the work of fifth century mural painters.

On the front a woman is visiting a grave monument. Dressed in a light chiton, her red hair gathered in a low knot at the nape, she stands tying a thick fillet (called taenia) around a grave stele, above two previously tied fillets (now faded); the terminal strings of the lowest fillet fall on the lowest step of the stele. She seems unaware of the man standing calmly at the right of the stele, looking in her direction. Is this the dead man and she thinks of him and pays him

honor? He is dressed in the clothing typical of a traveler: chitoniskos (short tunic), red cloak, petasos (broad hat) at his back. His hair is curly, shoulder length. He holds two spears in his right hand.

Since white ground vases most commonly show some aspect of death or funerary ritual, they provide an invaluable source of information concerning the funerary rites of the ancient Athenians. Many show visits to tombs with offerings placed on their steps—vases, ribbons, wreaths, and rarely food and drink.

Sometimes it is unclear who is depicted—whether the mourner or the deceased. On the Haverford lekythos, the young man may be dead since he wears the traveler's costume appropriate for one journeying to Hades, and he also holds two spears, a sign of heroization.

This artist is distinguished by the three dull red palmettes on the shoulder (a new Classical period type with sparse thin leaves, longer center leaf, diamond hearts), the crooked strokes of the black, detailed, meander, and the manner of drawing hands, arms, and face with small mouth and deep chin. Compare these details to the work of the Painter of Munich 2335, a painter of red-figure pots whose only lekythoi are white ground. His white ground lekythos iconography is funerary, his subjects repetitive (frequently the centerpiece is a beribboned tomb stele). His work is related to the Bird Group and was probably produced in the same workshop. His proveniences are Attic or Euboean. The vase's profile and palmette type suggest a date of ca. 440–420 B.C.

ANN ASHMEAD

CONDITION

Broken across the neck. The black glaze flaked on mouth and handle. White ground stained and worn. Considerable fading and loss of woman, notably, head, back, and lower body.

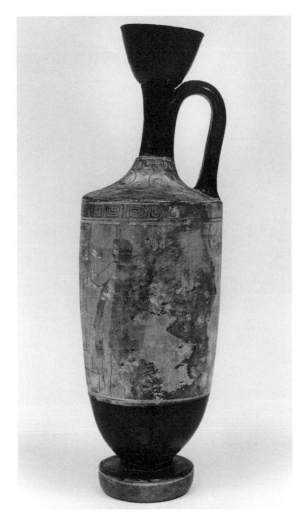

Figure 41 EA-1989-9. Attic White Ground lekythos. Right side. Attributed to the Painter of Munich 2335.

TECHNIQUE

Clay Fine orange-red. White ground gray-white, somewhat chalky. *Glaze* Glossy black fired red in lower body from kiln contact. Black are lip, neck and lower body, top of foot, handle, and interior of mouth. *Reserved* Rim of mouth, foot-rim, and the foot's resting surface. *Added Color:* see text. *Yellow-brown dilute glaze* Double lines frame the meander border; a single line marks the bottom of the scene. *Red miltos* Underneath foot.

SHAPE

A lekythos of near-cylinder shaped with conical mouth, strap handle with raised central ridge, short neck, sloping shoulder. The lower body curves towards the disk foot. *Incision* Line along upper edge of foot rim. The underside of the foot is deeply concave with a small center nipple.

DESCRIPTION

On shoulder is chain of three palmettes, linked by tendrils; central palmette is pendant, sides are horizontal and enclosed by tendrils which originate from central palmette. Their hearts are diamond shaped. Each has five petals. At join of neck and shoulder, band of egg pattern. On upper body, stopt meander border. Stele shaft has an ovolo (?) molding, and rests on a two stepped base.

BIBLIOGRAPHY

Unpublished

COMPARANDA

For white ground lekythoi: Boardman , *Red figure: Classical*, pp. 129–143; A. Fairbanks, *Athenian Lekythoi* ii, (London, 1914) and Kurtz, *AWL.* For a good accessible introduction to Greek burial customs, see Robt. Garland, *The Greek Way of Death* (Ithaca, 1985); see also D. C. Kurtz and J. Boardman, *Greek Burial Customs* (New York, 1971), p. 102.

For the palmette pattern see Kurtz, *AWL* fig. 23b. For the Painter of Munich 2335: *ARV*² pp. 1161–1170; white gd. pp. 1168–9. Kurtz, *AWL* pp. 52–56: the Painter of Munich 2335 has more feeling than the similar Bird Painter; he uses matte outlines. A frequent subject of his are youth and woman at tomb stele: for shape of tomb tied with ribbons, compare *ARV*² 1168, no. 135=Athens *CVA* 1 (1) pl. 8 (40) fig. 5-6=Kurtz; *AWL* pl. 41,3; and *ARV*² 1168, no. 139=Athens *CVA* 1 (1) pl. 8 (40) fig. 7-8. For hand and face of woman bringing ribbons: *ARV*² 1169, no. 142=Copenhagen *CVA* 4 (4) pl. 172

Figure 42 EA-1989-9. Drawing of profile.

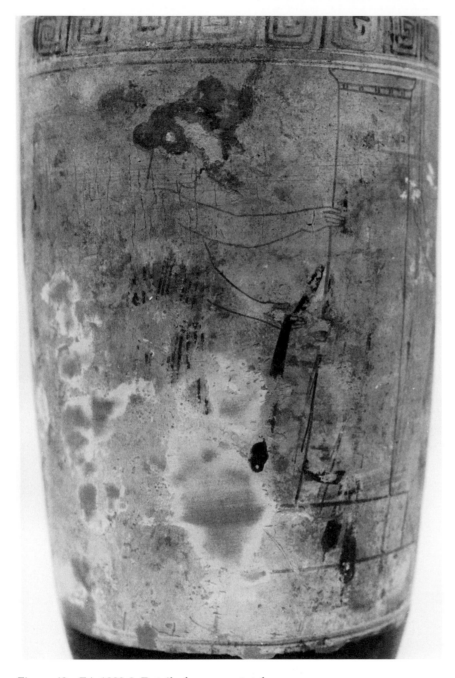

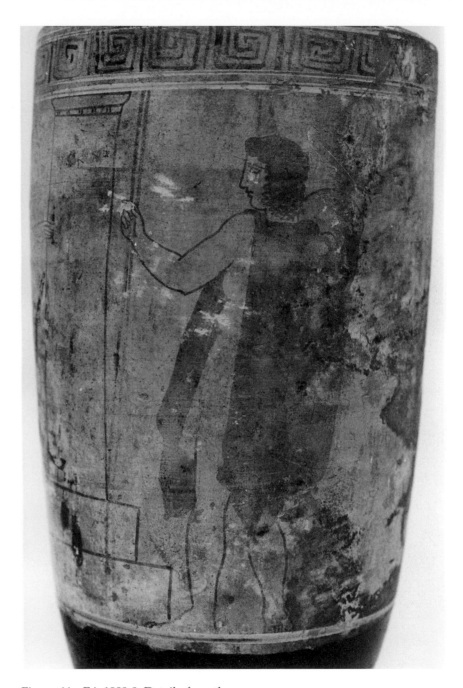

Figure 43 EA-1989-9. Detail of woman at stele.

Figure 44 EA-1989-9. Detail of youth.

Ann Ashmead

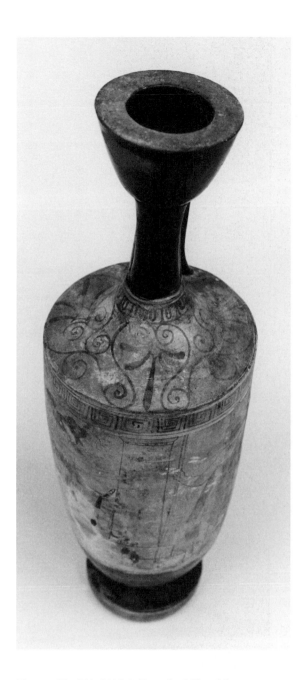

(175) no. 1. For drawing of upper arm of woman which continues over shoulder to back of neck: *ARV²* 1168, no. 131=Kurtz, *AWL* pl. 42,2; *ARV²* 1168, no. 132=Fairbanks, ii, pl. 7, 1.

For stop meander: *ARV²* 1168, no's 135=Athens *CVA* 1 (1) pl. 8 (40) fig. 5-6=Kurtz *AWL* pl. 41,3; *ARV²* 1168, no. 139=Athens *CVA* 1 (1) pl. 8 (40) fig. 7-8; *ARV²* 1169, no. 142=Copenhagen *CVA* 4 (4) pl. 172 (175) no. 1.

For vase shape and height: *ARV²* 1168, no. 139=Athens *CVA* 1 (1) pl. 8 (40) fig. 7–8.

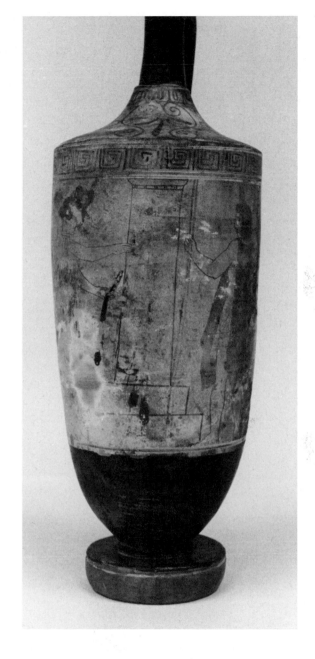

Figure 45 EA-1989-9. Detail of Shoulder.

Figure 46 EA-1989-9. Detail of front.

ATTIC RED-FIGURE PELIKE

Figures: 47–48
Accession number: EA-1989-11
Painter: Attributed to Aison by A. Ashmead.
Date: Circa 420–410 B.C.
Source: Purchased from Robert Hecht, Hesperia Art
Dimensions: H., 0.175 m.; D. of mouth, 0.120; D. of body, 0.156 m.;
 D. of foot, 0.128 m.

Athletic contests were an integral part of Greek life. Jumping—invariably in the form of the long jump—was a popular event in the Olympic *pentathlon* (five athletic contests). Here on Side A stand two nude athletes—at the left a jumper in profile right holds out two jumping weights, his right foot balanced behind him. Facing him is a nude, frontal athlete, wearing a fillet (faded) around his short curly hair; he holds two laurel sprigs (very faded) in each hand. Between these figures is an altar. On Side B a mantled young man, wearing a fillet, stands in profile left gesturing with his right arm toward the athletes. Below and above each scene is a band of tongue pattern.

Weights of bronze or stone were used by Greek jumpers to propel themselves forward and achieve greater distance. Although this youth at the left could be about to jump (as is the similarly posed jumper on a red-figure oinochoe, by the Disney Painter in Athens), his quiet, upright stance, the presence of an altar, and the four laurel sprigs (two in each hand) of his companion, raise the possibility that this youth is dedicating his weights after having already won the jumping contest and that he is about to be crowned with a laurel wreath.

This pelike (actually a variety of amphora) was mainly popular as an oil container, but is also represented on vases being used to hold wine and water. This particular small size was very popular in the late Classical period. The term, "pelike," was chosen by nineteenth-century archaeologists, but its application has no justification with written references.

The quality of drawing is good, even though the artist shows small signs of carelessness, i.e., the irregular altar base and weights, and the jumper's angular heel.

The style of the drawing is near that of Aison, a classical artist, one of the few painters whose name we know. Aison signed his name on a cup in Madrid painted with the Deeds of Theseus. Although a much grander cup, its style, as well as details (such as the double mid line above the navel of Theseus fighting Sinis, pro-

file face, hair curls), are comparable. Aison also painted a group of small pelikai of similar contour, some decorated with similar tongue pattern-bands, with athletes and youths similarly posed. An idiosyncratic detail, the dark band inside the altar contour on the Haverford pelike, was used by Aison on the altar between Apollo and Artemis, on a pelike in London.

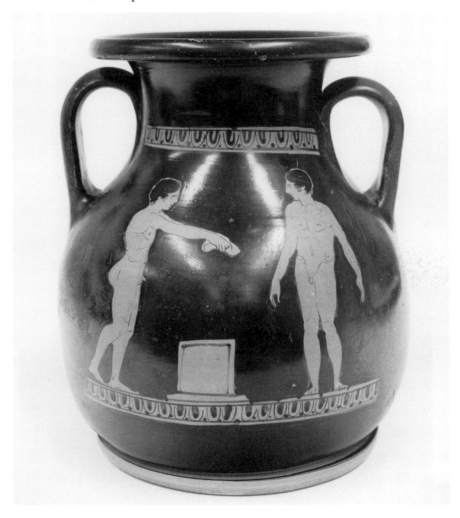

Figure 47 EA-1989-11. Attic Red-figure pelike. Circa 420–410 B.C. Side A. Jumper and youth. Attributed to Aison.

ANN ASHMEAD

CONDITION
Unbroken. Minor surface peeling.

TECHNIQUE
Clay Attic, orange toned. *Glaze* Glossy black inside, but body glaze, in large part, fired mottled reddish-brown. On this brown occur black spots (as if of brush spatter) and near base of B/A handle (left, seen from front) are "star bursts" of black lines. *Reserved* Heads of all figures. *Preliminary Sketch* Numerous lines. *Side A* Jumper: below upper edge of the r. arm and on its lower contour continuing across hand, as if hand were planned straight out. An arc, at shoulder, links his back and chest. His l. leg was planned further back, as indicated by sketch line down its center and another under glaze. R. leg also seems planned slightly (2–3 mm.) back, as indicated by line along its lead edge; heel round, not angular, in sketch. Other athlete's sketch line is easily confused with dilute glaze details although sketch line is on whole duller, wider, and marks out general lines. Sketch apparently contoured body, plus some inner details: curved stroke from eye to jaw sited head, lines on top of his shoulders, on his r. side, along his l. thigh, and down center of his torso. *Side B* Sketch wide, almost one mm., and artist pressed so hard that sketch instrument skipped, leaving little horizontal marks. Several wide curved strokes, from eye to neck; lines mark man's forward leg under his drapery, down to his ankle. Drapery mapped with a few diagonals, just for general direction. *Thinned Glaze* Carefully outlined figure contours. Visible along lips and chin, and a line continues into neck. Diluted contour subsequently covered by a thick glaze of contour strip. Bands inside altar. *Very Thinned Glaze* Very light and in places almost indistinguishable from preliminary sketch, but its lines are more curved. Muscles in forearms of frontal athlete (Side A.), within l. shoulder, serratus magnus (near his l. arm pit), central point of clavicle. Lines down center of r. thigh, muscle of l. lower leg. *Relief Contour Line* Very sparse. In frontal athlete, along upper inner contour of his r. arm, along r. thumb, along upper r. thigh, and upper inner l. arm which is continuation of stroke between chest and arm. *Eighth-inch Contour Strip* Around figure; cuts off lips and does not follow into chin area of jumper. *Added White* Much faded: laurel sprigs and fillets. *Miltos* Traces underneath and on foot rim.

LAYOUT AND SEQUENCE
The artist worked by framing each picture panel with lines, now covered over. This frame can be detected (on Side B) because of the contrasts in the glaze that was brushed on differently outside the frame: the background around the figures was filled in with a small brush, whereas the area outside the panel was glazed with a broad brush applied with vertical strokes; other broad brush strokes arc around the handles. The lower body and neck were glazed while the pot turned on the wheel, as evidenced by the horizontal brush strokes.

Black glaze covers the inside of the neck and the whole of the outside, except underneath and the edge of the foot. The interior is washed with dilute glaze.

SHAPE
Pelike. Flaring torus rim. Tooling marks remain under the rim, at the join of rim to neck. A strap handle, with round upper contour. Greatest pot width is at mid-body. Ring foot, ring gouged on its rim. The underside was incised with a circle (diam. 0.072 m.).

BIBLIOGRAPHY
Unpublished

COMPARANDA
See: Boardman, *Red Figure: Classical*, p. 147. Aison signed cup: Madrid, No. 11265, Museo Arquelogico Nacional, the Deeds of Theseus *ARV²*, 174, no. 1; E. Simon, *Die Griechischen Vasen* (Munich, 1981) figs. 221–223. Related Pelikai by Aison: For similar tongue pattern band: Tübingen, no. 679, *ARV²*, 1176, no. 31; for jumpers, *ARV²*, p. 1176, nos. 34–35; for athletes and youths similarly posed: Brussels R 353, *ARV²*, p. 1176, no. 36. For the dark band inside the altar : London British Museum, no. E.400; *ARV²*, 1176, no. 27; *LIMC* II, pl. 238, Apollon, 678, b, the altar between Apollo and Artemis.

For similar A and B grouping : Pelike, *ARV²*, p. 1176, no. 49. *Werke Antiker Kleinkunst*, Katalog 2, Dec. 1990, with A. Two nude athletes, B. mantled youth, connected to workshop of Aison. For *Jumper pose*: Disney Ptr., Athens Natl. Mus. no.1269: *ARV²*,1265, no. 13; *Mind and Body: Athletic Contests in Ancient Greece*, ed. Olga Tzachou-Alexandri (Athens, 1989) p. 168, no. 53.

The interpretation that the athlete is being crowned is a suggestion made to me by David Romano, The University of Pennsylvania Museum of Archaeology and Anthropology.

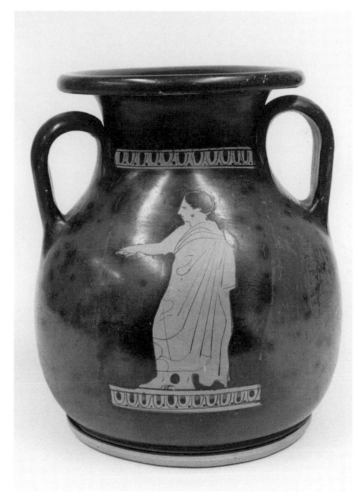

Figure 48 EA-1989-11. Side B.

ATTIC RED-FIGURE SKYPHOS

Figure: 49
Accession number: EA-1989-12
Painter: Unknown
Date: 425–400 B.C.
Source: Unknown. Purchased in Reading, Pennsylvania, ca. 1963 (see Introduction). Pencilled 876 on underside.
Dimensions: Ht., 0.072 m.; D. of rim, 0.093 m.; D. with handles, 0.151 m.; D. of foot, 0.059 m.; D. at stacking ring, ca. 0.090 m.

Numbers of two-handled, deep cups (called skyphoi) such as this one were decorated with owls. Owls frequently occur on both sides (an unusual practice with Greek vases). These owl skyphoi traveled widely around the Mediterranean, being popular perhaps as souvenirs.

Very slight details betray the artist's hand. Here, on each side we see a nearly identical surprised looking owl, between vertical olive branches. His body is to right, his squarish head (a slight dip in its center) faces front. His staring eyes are drawn as thick circles around a dot. His beak is shaped as a small "V." The lines of his wing converge at the tip. Small dots encircle his face, separate his head from body, and line his breast. The olive sprigs have a small leaf (cut off) at the top, and two fat pairs of opposed leaves, which lack a central rib. Below is a reserved band. The bottom is reserved except for the glazed resting surface. The interior is glazed.

The owl and olive were the patriotic symbols of Athens. They appear on the early coinage of the city, and the motif became canonical from the late sixth century B.C. Scholars speculate as to what this owl actually represents. Is the bird an attribute associated with Athena (as the thunderbolt is to Zeus)? Is this bird the symbol of Athena, standing in for the Goddess? Is it Athena herself, metamorphosed? Or does the owl symbolize a city cult of Athens?

The same artist who painted this painted an owl skyphos in Lyon, judging by the shape of the leaves (fat, ribless), owl, and the heavy eyes.

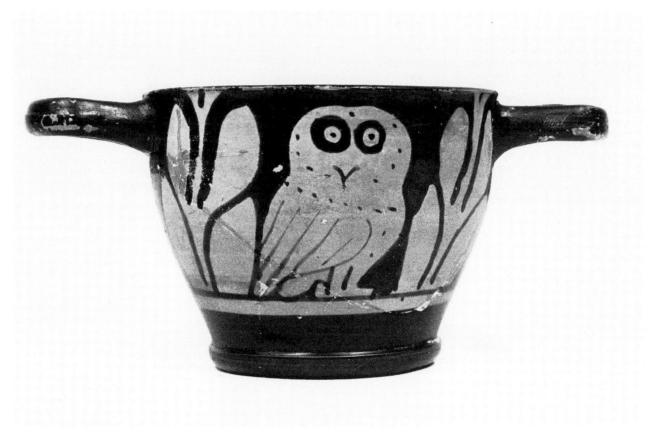

Figure 49 EA-1989-12. Attic Red-figure skyphos. Circa 425–400 B.C. Side A.

CONDITION

Complete, broken and mended. Repainted. Small chips missing from rim.

TECHNIQUE

Clay Attic fine, light rosy buff color. *Glaze* Semiglossy. Traces of kiln stacking visible at level of owl's "shoulders." Surface raised on Side B at beak level, from kiln contact. *Dilute Glaze* Wing feathers. *Miltos* Very pronounced in the upper half of the bowl (on leaves and heads) and some of the underside.

The artist's sequence of work on this vase was typical, from the bottom up. While the pot turned on the wheel, the painter marked two dilute lines slightly apart to locate the picture base, then, off the wheel, painted owl and branches standing on the upper line, then back on the wheel, glazed the lower body and added the thick base line.

SHAPE

Skyphos, Shape Type A. The lower body tapers inward slightly to foot. Horizontal handles, bent into an uneven horseshoe shape, attached at rim level; the handles are flat strips in cross section. Torus ring foot.

BIBLIOGRAPHY

Unpublished

COMPARANDA

PAINTER

For two closely related skyphoi by same painter, see Lyon, Musée des Beaux Arts, X 91: *Athènes: La Cité des Images* (Lyon, 1987), pp. 8–9, entry by Cl. Bérnard, ca. 425 B.C. and Farwell Skyphos, F. Johnson, *Studies Presented to David Robinson II* (St. Louis, 1953), pp. 96–105, Type II, pl. 32: compare eyes, beak, head shape, dots.

Brief discussion of owl skyphoi, Boardman, *Red Figure: Classical*, p. 39; ARV^2, pp. 982–984 with bibliography. Further bibliographical references in A. D. Trendall, *JHS,* 71 (1951) 192 (under no, 136). For an indepth analysis, see, F.P. Johnson, "A Note on Owl Skyphoi," *AJA* 59 (1955) 119–124 and pls. 35–38. For a recently published owl, assigned to Johnson's Group II, see, Private Collection, Cincin-

nati skyphos, Jenifer Neils, *Goddess and Polis: The Panathenaic Festival in Ancient Athens* (Princeton, 1992 p. 151, no. 11), dated ca. 450 B.C.

SHAPE

See Sparkes-Talcott, *Agora* 12, pp. 84–86 for discussion of shape, its origin, and development.

SYMBOLISM

The owl symbolizing a city cult of Athens, rather than Athena herself, is a suggestion proposed by Gloria Pinney.

DATE

Dates vary considerable: the date given for this skyphos (425–400 B.C.) is based on the Lyon skyphos (*supra*) by same painter. but the Haverford skyphos should be assigned to Johnson's Group II, (characterized by dotted lines paralleling the eyebrows) dated ca. 450 B.C.

Attic Figurine Vase: Lekythos with Offering Eros

Figure: 50
Accession number: EA-1989-23
Date: First half of the fourth century B.C.
Source: Purchased from the Estate of Samuel Chew, 1960.
Dimensions: H., 0.200 m.; W. of body, at wings, 0.072 m.; D. of rim, 0.029 m.;
 D. of base, 0.045 m.

The coroplast (modeler) here has combined the popular funerary lekythos with a statuette of the god Eros (God of Love, and symbol of the afterlife in funerary iconography). This delicate attractive vase may have been intended as a grave gift (or votive dedication—but the Greeks more commonly gave the dead vases rather than terracotta figurines). The vase may have held a tomb offering of scented oil (the narrow mouth made it possible to dispense oil by droplets). However, the fragility and fineness of this figure, the fact that the vase is secondary to the figure, and the extremely narrow neck, raise the question whether this vase was ever put to actual use. In fact it may have been privately collected for purely ornamental reasons.

This figure vase was formed by a coroplast. The modeled sections of the vase were formed separately in molds (the Eros, the rosettes, the wings); the back and handle were handmade; the mouth, neck, and base were turned on the wheel and obtained from a potter. All these parts were assembled by the coroplast, perhaps using glaze as an adhesive if necessary. The Eros' hair was worked over after molding, as was perhaps the surface of the filled phiale. After the vase was assembled and dried, black glaze and slip (on the modeled areas) were applied. The vase was then fired. After firing, bright colors (here turquoise, rose, and others since vanished) were painted on the modeled areas.

An offering Eros, enclosed by his large wings, stands in a classical pose, frontally on a round base, extending a phiale in his left hand, and holding a trefoil oinochoe at his side, in the other. His head is tipped slightly down, turned to his left. His long, wavy pink-brown hair falls on his shoulders and is blown back against his wing. His nude body was originally white (?); a pink cloak hangs down from his left shoulder. He puts his weight on his straight right leg, the foot in profile, the other leg is slightly bent and frontal. His long, brilliant turquoise-green wings shelter his body and reach to his feet. Two rosettes cover his wing tips. The rest of the vase is black: exterior of mouth and rim, handle, neck, back, lower molding of pedestal, resting surface and a raised ring on bottom.

This molded Eros is more a relief-figure than three dimensional. His phiale and oinochoe imply his role in libations. This Eros is unique ; a comparable but not identical molded Eros carrying phiale and oinochoe is in the British Museum. Other examples represent Eros as escort to his mother Aphrodite, or carrying cult objects such as incense burners, or toiletry boxes, or toys. Since a child, Eros was a great lover of games.

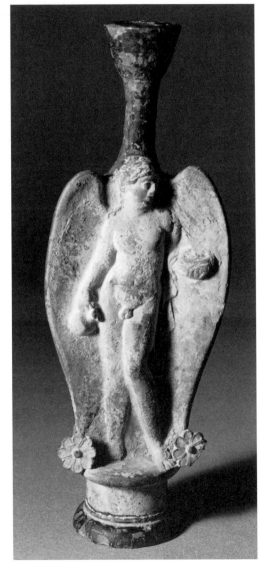

Figure 50 EA-1989-23. Attic figurine lekythos. Offering Eros. Circa 400–350 B.C.

ANN ASHMEAD

CONDITION

Complete, but broken. The neck breaks are heavily restored; breaks across wing tips and handle. Chipped on base and r. rosette. Incrustation on back. The black surfaces are heavily repainted. The white on the body is mainly lost, now only retained where body joins wings. The turquoise of the wings is partially flaked off; the base color is now indeterminate.

TECHNIQUE

Clay Pink-buff. Mold-made: Eros. Wheel turned: mouth, neck, base. *Glaze* Medium glossy black. *Added color: Matte rose* Drapery, hair. *White slip* Body. *Brilliant turquoise blue-green* inside wings.

SHAPE

A small figurine vase in the shape of a winged Eros, with vase, body, neck, and mouth of lekythos form. The mouth is tall, rather straight-sided, the neck is slender; a groove marks their juncture. The ridged handle has a flat inner contour. The spool-shaped pedestal has convex rims, with a round filler above the base rim. The base underside is recessed but for a narrow ring.

BIBLIOGRAPHY

Unpublished

COMPARANDA

For additional bibliography and discussion of the figurine vase, see Ellen Reader Williams, "Figurine Vases from the Athenian Agora," *Hesp.* 47 (1978) pp. 356–401. Types and meanings of plastic vases with Eros are discussed by Maria Trumpf-Lyritzaki, *Griechische Figurenvasen des Reichen Slils und der späten Klassik* (Bonn, 1969) pp. 12–51; 129–131.

On technique of assembly, see Williams, *Hesp.* 47 (1978) pp. 359–360.

On theory of private collections for purely ornamental reasons, see Williams, *ibid.* p. 387.

For the offering Eros type see British Museum no. 1717, R.A Higgins, *Catalogue of the Terracottas, vol. II* (London, 1959), pl. 42, and pp. 57, 67–8 and also Winter, II, p. 246, no. 2.

BOEOTIAN CUP WITH HIGH FOOT

Figures: 51–52
Accession number: EA-1989-14
Painter: Unknown
Date: Circa 550 B.C.
Source: Purchased from Robert Hecht, Hesperia Art.
Dimensions: H., 0.164 m.; D. of bowl, 0.238 m.; D. including handles, 0.294 m.;
 D. of foot, 0.101 m.

A Boeotian shaft grave was surely once the resting place of this stemmed bowl. Too large and cumbersome for drinking, this cup would have been considered suitable as a grave offering, and its type has been excavated at Rhitsona, in Boeotia, exclusively from graves. The decorative schema is typical (in fact it is called the Boeotian Kylix style). The decoration of the Haverford cup belongs to Class Ib of the style, determined by the use of panels of palmette patterns alternating with panels of herringbone patterns, and by the colors—black and a reddish brown paint on a creamy ground. Birds were used to decorate many of bowls, hence their other name, "Bird Bowls"—as were lotus flowers, rosettes, spirals.

The shape is easily recognizable. The bowl, quite deep and rounded, sits on a high foot that flares out at the base. Four horizontal strap handles are attached at equal intervals around the bowl, just below the rim. The rim here is flat on top, and overhangs the bowl exterior slightly. The foot rim is vertical.

The internal evolution of these bowls is as yet unclear, although the chronological limits of the shaft graves are set. The Haverford bowl may be as early as the second quarter of the sixth century.

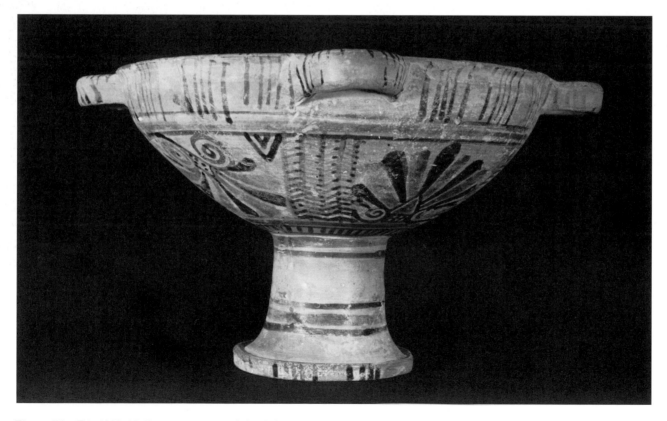

Figure 51 EA-1989-14. Boeotian cup with high foot. Circa 550 B.C. Profile.

ANN ASHMEAD

Condition

Complete. Broken into large pieces and mended. The design is worn, the paint slightly faded.

Technique

Clay Fine buff-colored clay. Cream engobe on all surfaces.

Decoration

In dull black and reddish purple. The main body is divided into four wide panels of palmettes, separated by narrower panels of two rows of vertical herringbone (red verticals, black cross strokes). The palmettes point alternately up and down; they have triangular hearts, three of which are filled with black dots, and one with a solid triangle of added red. Palmette leaves are alternately purple and black. The top of the lip, the handles, and the rim of the foot are decorated with groups of five black strokes. A band of black strokes appears at base of bowl. A red band between thin black bands appears above and below the palmette frieze, as well as twice on the foot, and underneath, inside the foot. On the interior are two broad concentric circles of black around a red center disk.

Bibliography

Unpublished

Comparanda

Shape and Palmette Pattern

See P. N. Ure, *Sixth and Fifth Century Pottery from Excavations Made at Rhitsona by R. M. Burrow in 1909 and by P. N. Ure in 1921 and 1922* (London, 1927) pl. 4, 126.2 and p. 13. For some recent discussions and publications of Boeotian birdbowls: see N. Kunisch, *CVA* Berlin 4 [33], pp. 55-56; Kl. Wallenstein, *CVA* Tübingen 1 [36], p. 71.

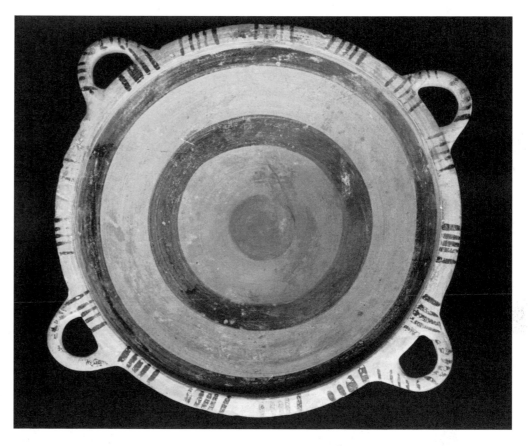

Figure 52 EA-1989-14. Boeotian cup. Interior.

HELLENISTIC LAGYNOS

Figure: 53
Accession number: EA-1989-15
Painter: Unknown
Date: Hellenistic. Late third or early second century B.C.
Source: Purchased from Robert Hecht, Hesperia Art. Probably from Cyrene.
Dimensions: H., 0.143 m.; H. with handle, 0.148 m.; D. of body, 0.186 m.;
 D. of foot, 0.135 m.

The excellent unbroken state of this particular lagynos (wine jug) makes it exceptional. But a lagynos merits attention on many grounds—not only for the originality of its shape (unknown in the classical period) and decoration, but also because historical and literary texts refer to it as a shape accessory at certain banquets. Distinctive are its tall, narrow, almost cylindrical neck, vertical handle (bent at an angle), and low, wide body.

This style of decoration, monochrome brown glaze on white engobe, is ancient. Naturalistic motifs predominate on lagynoi; floral motifs, musical instruments, or crowns (such as here at the shoulder) are typical of the Hellenistic period. This crown motif, composed of bow-knotted ribbons tieing up a garland, is suggestive of the banquet; it occurs on lagynoi found at Pergamon.

The origin of lagynoi is difficult to determine. They are long lived, from the second half of the third century B.C. until the first century B.C. or later, and are found widely—on the mainland of Greece, on Delos, Melos, in Asia Minor, Cyrene, and elsewhere—but with local variations in shape. The particular shape of the Haverford lagynos (i.e., relatively short neck, swelling shoulder, sharp body-to-shoulder angle, wide body, thick lip) compares to lagynoi from the Lybian-Pentapolis, Cyrene. The incurve to the lip is suitable for catching drops of its oil contents.

The sturdy handle and commodious body makes the lagynos eminently portable. During ancient festivals in honor of Dionysos, each symposiast, garlanded, would carry his own jug to a banquet. The leaf garland painted on the shoulder of the Haverford pot reflects living garlands that may have crowned the jug at the festival.

The shape, because of its particularly narrow neck, was chosen for illustrations of Aesop's fable of the Fox and the Stork, in which the stork tricks his foxy guest who is unable to drink through the vessel's opening.

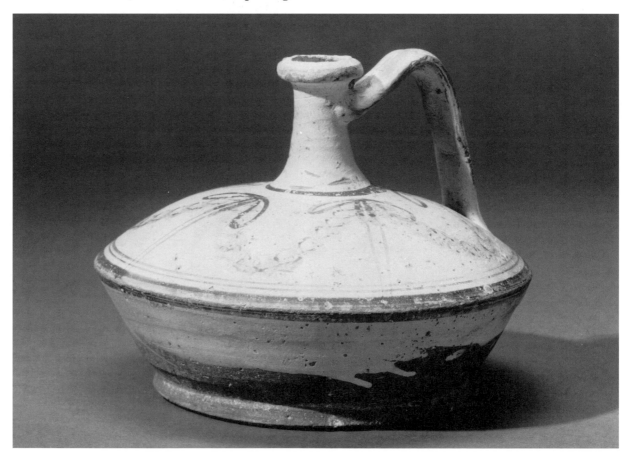

Figure 53 EA-1989-15. Hellenistic lagynos. Late third or early second century B.C. Right side.

ANN ASHMEAD

CONDITION

Excellent: complete, handle broken, mended. White slip worn off handle. Surface slightly pocked from inclusions in clay bursting during firing. Some gouges on neck.

TECHNIQUE

Clay Light brown color, with mica. *Slip* Creamy white. *Glaze* Semiglossy, dark brown turning to orange. *Reserved* Underside and lower half of sides.

SHAPE

Lagynos. Low, wide body, with relatively short neck, round thick lip, strap handle that is doubly grooved, and a ring foot.

DECORATION

The vase was first covered with a creamy white slip, on neck, handle, and upper half of the body (splashes and brush-strokes remain where the slip ends). On top of this slip, on the shoulder, were painted five orange-brown knotted bows tieing up a garland painted as linked circles. Bands of brown glaze rings were added on the lip, the root of the neck, junction of the shoulder to side-wall; two narrow thin orange-brown bands accent the shoulder.

BIBILIOGRAPHY

Hesperia Art 39, no. A 16. Illustrated on the cover (top and profile).

COMPARANA

Gabriel Leroux, *Lagynos: Recherches sur La Céramique et L'Art Ornamental Hellénistiques* (Paris, 1913). For the shape: Leroux (*supra*), p. 36, Louvre no. 142. from Cyrene. Leroux (*supra*), pp. 91–99, discusses characteristic lagynoi motifs.

For the garland motif: J. Schafer, *Hellenistische Keramik aus Pergamon=Pergaenische Forshungen ii* (Berlin 1968) pl. 43, F 13, but these chain links are solid, rather than open. The motif of bow-knots (but no garland) occurs on an example found in the Agora, P 3375: H. A. Thompson, "Two Centuries of Hellenistic Pottery," *Hesp.* 3 (1934) p. 403, E 70, fig. 92.

For ancient references to the shape, see Leroux (*supra*), pp. 78–81. For lagynoi, as used in the ancient cult of Dionysos, see Leroux (*supra*), p. 79.

The problems surrounding the chronology and sources of lagynoi are clearly set out by Schafer (*supra*) pp. 110–113.

TERRACOTTA RELIEFS: PHRYGIAN OR EAST GREEK

Plate: 54–55
Accession number: EA-1989-18: a and b
Date: Sixth century B.C.
Source: Purchased from Robert Hecht, Hesperia Art. Possibly from Düver.
Dimensions:
Plaque 18a Pres. H., 0.251; Pres. W., 0.160 m.; Depth at the lower molding,
 0.039 m.; Depth at lower edge (through griffin's foot) 0.026 m.; Depth at upper
 edge (measured through black band) 0.035 m.
Plaque 18b: Pres. H., 0.269 m.; Pres. W. 0.290 m.; Depth at lower molding,
 0.039 m.; Depth at lower edge (at griffin's foot), 0.028 m.; depth at upper edge
 (measured at black band), 0.420 m.

Protecting and decorating ancient buildings with terracotta facings was a common practice in parts of the Mediterranean world. This practice, probably invented in Corinth in the second half of the seventh century, traveled west to Etruria, South Italy, and Sicily and east to Anatolia.

These two boldly decorated, colorful terracotta fragments ("a" one-third preserved, "b" one-half preserved) come from an Archaic building near the citadel of Düver, 10 km. west of Hacilar in southwest Turkey—a major building discovered and, most unfortunately, looted in or shortly before 1964. A relief frieze of galloping or cantering horsemen alternating with sturdy griffins striding right, fronted the lateral cornice at the top of the wall of one building. At least twenty examples of this horseman-griffin frieze are known scattered in museums around the world.

Scholars have attempted to reconstruct the structure and roofing of the lost building from these frieze plaques and roof tiles. The rectangular plaques (revetments) were used to sheath (protect) and decorate horizontal wooden beams on the half-timbered building. The holes (originally two in each complete plaque) served to attach the relief to the horizontal timber cornice, probably by means of wooden pegs. The plaques were constructed with a horizontal piece—missing from the Haverford example—that attached behind the upper molding and extended back over the top of the wooden beam.

Although only the rider's foot is preserved on "b," we know from other slabs that the complete rider was long-haired, bearded, and wore Anatolian dress, a tunic with maeander pattern at neck and sleeves, striped trousers, and low boots. On other slabs in the frieze, the griffin bodies were either red or black, their wings picked out in color in various patterns. Certain details of slab "b" (the griffin's teeth and ear-dots, harness with pomegranate-shaped projection, the striped mane) are faded so they are best seen on a better preserved plaque from Düver, in a color illustration. For the style of round knob and feathers compare a plaque in Stockholm.

The style is Phrygian. Phrygia was a powerful state in Asia Minor, whose capitol was Gordion. In the eighth century B.C., the empire was founded by Midas (he of the Golden Touch) and ruled by kings alternately named Gordius and Midas. The red and black painted decoration on the plaques is typically late Phrygian in technique, but the unpainted relief has a strong East Greek imprint.

The griffin was a beaked quadruped, a wild mythical animal found in the mountains, with a body like a lion, wings and mask like an eagle. It is supposed to be violently hostile to horses. This griffin head is reminiscent of bronze griffin-head attachments on the great Olympia bronze cauldrons. Typically this exotic Eastern creature has a scaly neck, tall narrow pricked ears, a top-knot, and a wide-open sharply curved beak with a raised tongue within.

The legendary, gold-guarding griffin's origins may stem from the coincidence of fossils of beaked dinosaurs common in deserts where ancient Isedonian (Asian) nomads searched for gold. Perhaps this Phrygian frieze is an abstract depiction of gold seeking— the griffins signifying where to find gold. The relief griffin seems to be leading the horse, the rider gesturing in pursuit, rather than the more common image of the griffin battling. Even the red, cream, and black colors of the griffin from this plaque are the very colors Aelian, a second-century A.D. Roman naturalist, ascribes to the plumage of griffins.

Although these reliefs were at some distance above the viewer, details such as the small teeth, flipped up tongue, dots on ears, and head band on "b"—details that would be nearly invisible from below—were nevertheless indicated.

Two different artisans molded these two slabs, judging by the technical differences (greater thickness of "b" at upper edge, flat back); two artists also painted these slabs, judging by the dissimilarity of details (different pattern of the lower molding, knob and ear patterns). Lastly, these decorative slabs are a sad testament to architectural knowledge so recently lost to illicit digging.

ANN ASHMEAD

CONDITION

In both plaques the l. half and upper moldings are lost. Plaque "a" is chipped at the corners and has a clay gap in rear leg of griffin; "b" is broken horizontally at the level of the horse's nose. Dirt around the figures on "b;" "a" has been cleaned, except around lower r. corner.

TECHNIQUE

Formed in a flat mold. *Clay* Reddish brown with a pale grey core; numerous coarse sandy grit inclusions. More white inclusions on "a" and more blowouts; some mica on "b." *Color Cream* Ground on "a;" on "b" the ground is darker, as cream background is faded. *Matte Red and Black* Horse, griffin, rider; the red on "a" is browner, that on "b" is more purple.

SHAPE

Rectangular panels, once approximately 43.5 wide and 35.5 high (with upper molding preserved); the upper crown molding, a half-round (torus), is now lost; a rectangluar molding forms the bottom edge. Both fragments come from the right end. The slabs differ in thickness (slab "a" is thinner than "b;" the back of "a" is slightly recessed, that of slab "b" is flat). Each slab has an attachment hole at the upper rt. The placement of the holes is as follows: "a"—distance from the right edge is 0.069 and 0.078 cm up from the bottom; "b"—distance from the right edge is 0.058, distance from the bottom edge 0.085 cm. The holes are dissimilar in the back: on "a" excess clay rings, and projects from the back opening, whereas on slab "b" there are traces that this excess clay was scraped off with a piece of wood. The holes were pushed through the moist clay from the front before firing. They slope up slightly toward the rear.

DESCRIPTION

Slab "a": A colorful griffin, in relief, walking r., spiral plume trailing out behind his head, mouth open, tongue up; his tail, rump and rear r. leg are lost. He is capriciously painted with a red neck and torso, mostly black legs; his cream-colored wings sport red feathers outlined in black. Red for his head, tongue (traces of black underneath), spike

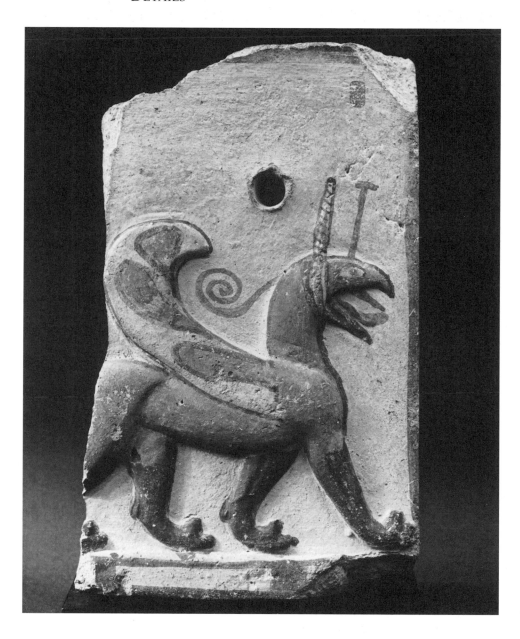

Figure 54 EA-1989-18a. Phrygian terracotta relief. Sixth century B.C. Griffin.

projecting from mouth, head-spike, and spiral plume. Black for lower jaw, eye contour and pupil, strokes across ear and neck and outlining his body. The molding below is painted with black squares alternating with long reserved rectangles. The underside is unglazed. A red rectangle "cartouche" with rounded corners, in the upper right; may or may not have been solidly painted.

Slab "b": A galloping horse decoratively harnessed, a rider, and a griffin walking r., his tail raised and waving. Only the foot of the rider and the horse's head and forelegs are preserved. The horse has a red body but black on his upper-legs and hooves. His headstall was picked out in red, his mane is painted alternately red and black and ground color; a leather flap hangs from a band of meander-patterned harness around his chest, and a huge pomegranate-shaped decoration (red inside with black dots) protrudes in front. The man's foot is red with black edging; black edging also on the horse's body and legs. The griffin's body is completely black; he has a black tail with "eye" at tip, face and eye-pupil; black outline around his wing, neck, ear and jaw. Red for wing feathers, pomegranate-shaped knob on his head, dots in ear, teeth and tongue. The background is red.

Molding below roughly daubed with alternate rectangles of black and red separated by rectangles of ground color. Underside of the molding glazed black. On both slabs black line along the r. side.

Certain facts about slab "a" seem peculiar: i.e., the rough edge where the leg-black stops, the unnecessary mouth spike (an error on the upper contour of a thick tongue), the shapes of the griffin's crest and wing-feathers (M. J. Mellink expressed her doubts to me about this detail in particular), the unusual elongated, blunt tipped ear, and the lighter ground color. Is slab "a" a forgery? Surely not since the clay, and technique of the slab (i.e., the slanted attachment hole, the color) seem authentic.

DATE

Sixth century B.C. Widely dated by scholars. First half of the sixth century (Nicholas Thomas *JHS* 85 [1965] p. 70); mid-sixth century B.C. (M. J. Mellink *AJA* 68 [1964] p. 159); third-quarter of the sixth century B.C. (Ä. Äkerström, "A Horseman from Asia Minor," *Medelhavsmuseet Bulletin* 4 [1964] p. 33; and *Die architektonischen Terrakotten*

Kleinasiens, [Lund, 1966] p. 221); 540–530 B.C. (N. Winter, *Greek Architectural Terracottas from the Prehistoric Period to the End of the Archaic Period* [Oxford 1993]); end of sixth century B.C. (E. Akurgal, *Orient and Okzident,* p. 220; F.L. Bastet, "Zwei Neuerwerbungen des Rijksmuseum van Oudheden in Leiden." *BABesch,* 57 [1982] p. 155).

BIBLIOGRAPHY

Hesperia Art Bulletin, 49, nos. 41 and 42; Nicholas Thomas, *Archaeological Reports for 1964–65, JHS* 85 (1965) 64ff: refers to examples in America, possibly these at Haverford.

COMPARANDA

OTHER PLAQUES

Numerous architectural terracottas (both horseman-griffin and geometric design) are scattered in at least 16 museums (America Columbia, Mo., Houston, Tx., Malibu, Calif., Richmond, Va.; Amsterdam; Australia Adelaide, Canberra,

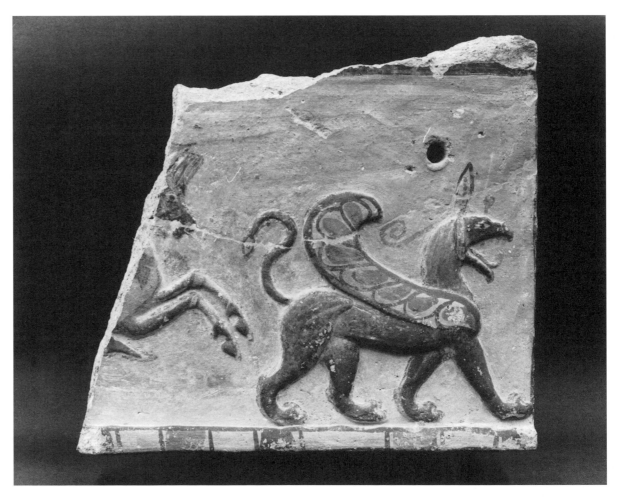

Figure 55 EA-1989-18b. Phrygian East Greek terracotta relief. Sixth century B.C. Horseman and griffin.

St. Lucia, information from Brunilde Ridgway]; Berlin; Birmingham; Jerusalem; Leiden; Paris; Stockholm; and Turkey Burdur, Istanbul). Numerous examples of just this horseman-griffin frieze are known equally scattered in some of the above museums (15 Richmond, Va.).

Plaques of both types (horseman-griffin and geometric) were sold at auction at Sotheby's in London, Cat. Sale 24th February 1964, Nr. 50–64; 6th July 1964, Nr. 45–56; 28th June 1965, Nr. 89–92; and Spink and Son, Feb. 1964, fragments. And *Auktion XX*, November 19, 1970. In the same sale as EA 1989 18, *Hesperia Art* 49, offered a horseman and rider plaque (no. 40): its present whereabouts is not known to me. Note that the origin of the Berlin plaque, cited above is unknown.

For further details on these plaque sales and present locations see M. Mayo, "Architectural Terracottas from Phrygia," *Arts in Virginia* Vol. 21, no. 2 (Winter 1981) pp. 29–35, especially n. 6. Mayo's references include plaques of the geometric style, belonging to a second building. See also N. Thomas, *JHS* 85 (1965) p. 64, and F. L. Bastet, "Zwei Neuerwerbungen des Rijksmuseum van Oudheden in Leiden."*BABesch* 57 (1982) p. 153.

For a reconstruction of the relief frieze of horsemen alternating with griffin walking on lateral cornice: see Ä. Äkerström, *Die architektonischen Terrakotten Kleinasiens* (Lund, 1966) p. 256, fig. 75, = A. Greifenhagen, *AA* 81 (1966) p. 47, fig. 2; the same is modified by Mayo, supra. p. 32, fig. 17. See N. Thomas *JHS* 85 (1965) p. 66, fig. 5 for a frontal view with colors indicated. For a color illustration of a horseman and griffin plaque: Ekrem Akurgal, *Orient and Okzident* (Baden-Baden, 1966) p. 220, fig. 68.

For the style of round knob and feathers compare a plaque in Stockholm (Ä. Äkerström, *Die architektonischen Terrakotten Kleinasiens* (Lund, 1966) p. 219, fig. 70, no. 1). Also compare the feathers of Haverford College plaque "a" with Richmond 78.62.13 (Mayo, *op. cit.* p. 30, fig. 3; feathers of "b" to Richmond 78.62.7–8. Mayo, *op. cit.* p. 31, figs. 6 and 10.) For the style of griffin head, compare bronze griffin heads: Ulf Jantzen, *Griechische Greifenkessel,* (Berlin, 1955).

For the roof tiles and hypothetical reconstruction of the building, see W. W. Cummer, "Phrygian Roof Tiles in the Burdur Museum," *Anadolou* (=*Anatolia*) 14 (1970) pp. 29–71, reconstruction pp. 53–4, figs. 10–11.

On griffins as indicators of gold, see A. Mayor and M. Heaney, "Griffins and Arimaspeans," *Folklore* vol. 104 (1993) pp. 40–66 esp. p. 61, n. 14 on Aelian; and A. Mayor, "Guardians of the Gold" *Archaeology* 47, no. 6 Nov/Dec 1994, pp. 53–59, p. 58, color photo is reversed.

Western Greek Terracotta: Reclining Banqueter, Taranto

Plate: 56
Accession number: EA-1989-20
Date: Early fifth century B.C.
Source: Purchased from the Chapman Estate, in Philadelphia.
Dimensions: Pres. H., 0.053 m.; W., 0.045 m.

Terracotta images were widely used in religious rites by ancient Mediterranean people. This and the following three terracottas came from Taranto (ancient Taras) judging by their clay, technique, style, and subject. Taranto was a Greek colony established by the Laconians in ca. 706 B.C. on the south coast of Italy near where the heel joins the arch of the boot; it was one of the most flourishing centers of Greek art in the West. Cheap, mass-produced terracotta statuettes similar to these four were found in a votive deposit containing tens of thousands of terracottas by the shore of the inland harbor at Taranto, where modern Italian sailors still debark today.

Figurines, such as these, were made and sold at major sanctuaries for offerings. They were worked by coroplasts (molders of small figures) in small shops near the shrines and temples. Already baked and brightly painted, they were sold to customers who placed them in the precincts of the deities as acts of devotion. When the sanctuary became full, the excess was removed by the priests, deliberately broken (in most cases), as is EA-1989-20, to prevent reuse, and buried in trenches nearby, usually class by class. This practice, apart from the fragility of terracottas, explains why heads, like the two in this collection, are common. The votive cult at Taranto had flourished at the site for more than four hundred years.

These terracotta pieces were usually (unlike EA-1989-19) made without backs and supported behind by vertical struts. By far the commonest type of Tarantine terracotta is a reclining male. The type had an unusually long life, from about 500 to about 330 B.C., during which time the heads and the renderings of figures were constantly updated. Reclining body molds could be fitted with differing head molds, permitting bearded/unbearded heads, or heads with differing styles of headdress to be interchanged. What looks like a necklace or collar-bones on EA-1989-20 may actually be explained as the demarcation line between head and body mold.

This particular youthful banqueter (EA-1989-20) reclines on his left side on a couch, supporting himself on his l. elbow, which rests on a pillow. His right hand touches his right knee, which is bent; in his left hand he holds a phiale against his body. He wears a himation which covers him from the waist downwards. His anatomical markings are geometric and pronounced; his drapery folds stiff and straight. His face is ovoid, his chin pointed. His hair arches over his forehead in tight curls, ovoid in shape, and falls on his shoulders. The couch, overlaid with a mattress, originally stood on high legs.

Who is this reclining male? He is a banqueter, as he reclines in the ancient style of dining. (This banquet symbolizes the offering of food to a deity to obtain divine protection.) Previously scholars have identify him as Dionysos-Hades, believing the votive deposit must have belonged to the Sanctuary of Dionysos, and the symbolism to be funerary—the funeral banquet. But recent scholars attest that it is important to separate the funerary banquet from banquets indicating status or hero worship. For them the figurines were part of a cult which honored some hero long important to the city, heroes such as one of the divine twins, Castor or Pollox, or Phalanthos, the hero-founder of the city. A youthful hero seems the more appropriate identification for this beardless example, rather than a god.

ANN ASHMEAD

CONDITION

Fragmentary. Missing are the r. leg of the couch. Incrusted.

TECHNIQUE

Clay Rosy cream with fine mica. The front of the figure is mold-made, the back is roughly filled flat, and hand smoothed. In the couch leg the front mold has separated slightly from the filler clay. *Color* White slip.

DATE

Judging by his face, the stiff diagonal lines of the himation across his legs, and the pronounced orderly subdivisions of his stomach anatomy, this banqueter was made early in the fifth century B.C. Compare him stylistically to Winter, i, 198, no. 7: Iacobone (*infra*), p. 57, Type C, XIII, pl. 146; Higgins, *Catalogue, Br. Mus.* p. 337, no. 1237, pl. 170.

BIBLIOGRAPHY

Unpublished

COMPARANDA

The banqueter and its identification are discussed by the following: Higgins, *Catalogue Br. Mus.,* p. 336; B. Neutsch, "Der Heros auf der Kline" *RM* 68 (1961), pp. 150–163, pls. 62–72; Helga Herdejürgen, *Die tarentinischen Terrakotten des 6. bis 4 Jahrhunderts v. Chr. im Antikenmuseum Basel* (Basel, 1971), pp. 26–33; J. M. Dentzer "Le motif du banquet couché dans le Proche-Orient et le monde grec du VIIe siècle au IV av. J.-C., *Mélanges d'Archeologie et d'Histoire, Antiquité* 1975, 190 ff. (Magna Grecia and Taranto); also Bonnie M. Kingsley. "Tarentine Moulds and Reliefs in the J. Paul Getty Museum," Ph.D. Dissertation (Ann Arbor 1981) pp. 117–137; 263–281); Simone Besques, *RA* 1985, pp. 77–108, S. Italy, Sicily and Sardinia, especially pp. 106–107. More recently, Clelia Iacobone, *Le Stipi Votive di Taranto* (Scavi 1885–1934) (Rome, 1988) pp. 166–169 (type C) plus its review by Ingrid Edlund-Berry, *AJA* 97 (1993), pp. 181–182.

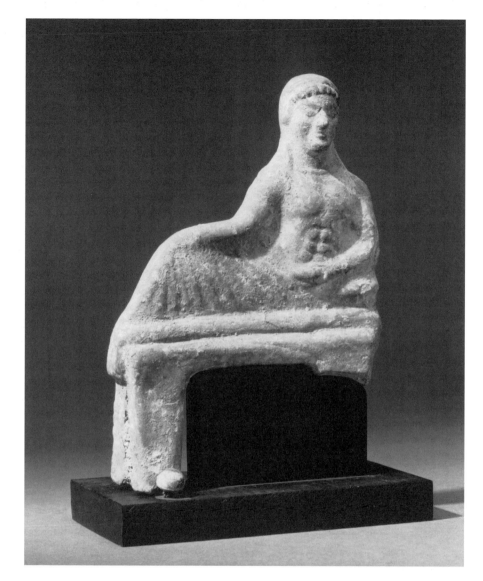

Figure 56 EA-1989-20. West Greek terracotta. Reclining male. Early fifth century B.C.

Western Greek Terracotta: Reclining Banqueter, Taranto

Plate: 57–58
Accession number: EA-1989-22a
Date: Mid-fifth century B.C.
Source: Purchased from the Chapman Estate, in Philadelphia.
Dimensions: Pres. H., 0.141 m.; Pres. W., 0.105 m. at lower arms.

This piece conserves the head and upper torso of a reclining banqueter, who has a rectangular face, a projecting beard skewed to his r. and somewhat pointed at the tip, and a pursed mouth. His hair crosses his forehead horizontally and projects over the ears. He wears a beaded diadem, and a stephane (an ornament of metal for the hair in the shape of a crescent tapering towards the ends); on its raised central portion is a lotus (or palmette?) ornament. His pectoral muscles project, and four divisions are marked out on torso below.

The reclining banqueter type is discussed under entries EA-1989-20 and EA-1989-19. This male head and torso is larger in size than those examples. His beard—more pointed than that of EA-1989-19—also suggests an identification with Dionysos. His headdress, although similar to EA-1989-19, differs in details (his diadem is horizontal across the forehead, the beads are larger).

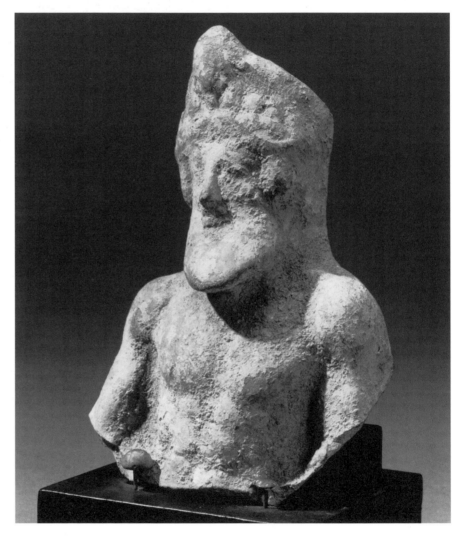

Figure 57 EA-1989-22a. West Greek terracotta. Male head and torso. Mid-fifth century B.C.

ANN ASHMEAD

CONDITION

Fragmentary. Broken across the waist. The lower body and couch are missing. Incrusted on front.

TECHNIQUE

Clay Gray color with fine mica. The front of the figure is mold-made. The reverse side is concave, hand smoothed. Deep hollow behind head. *Color* White slip.

BIBLIOGRAPHY

Unpublished

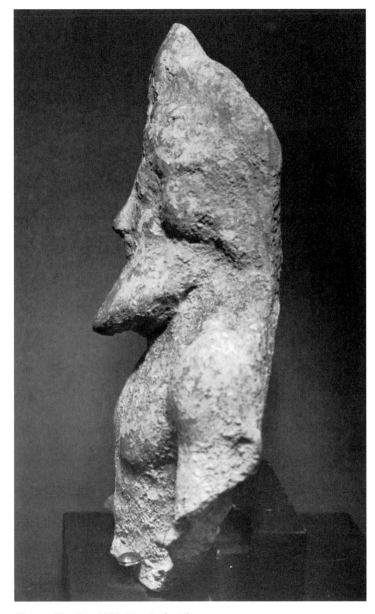

Figure 58 EA-1989-22a. Left side.

WESTERN GREEK TERRACOTTA: BEARDED HEAD OF BANQUETER, TARANTO

Plate: 59
Accession Number: EA-1989-22b
Date: Mid-fifth century B.C.
Source: Purchased from the Chapman Estate, in Philadelphia.
Dimensions: H. (beard tip to head ornament), 0.115 m.; Pres. W.
 (at headdress), 0.076 m.

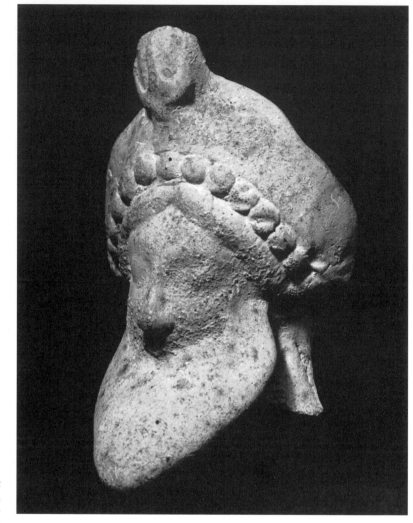

Figure 59 EA-1989-22b. West Greek terracotta. Bearded male head. Mid-fifth century B.C.

This bearded male head is broken from its body. (See EA-1989-20 for type.) His hair is centrally parted, over a triangular forehead. He has a broad face, with large eyes and nose, and a very large, strongly projecting triangular beard (attached separately) that tapers to a very sharp point. He wears a beaded diadem (the beads large and round) and a stephane (a metal hair ornament in the form of a crescent-shaped band tapering towards its ends) that has on its raised central portion a lotus ornament in relief.

This head is of the type attached to reclining banqueters, such as Haverford Terracottas EA-989-20, and -19, but it is considerably larger than those examples. The headdress is similar to EA-1989-19, and EA-1989-22a, but differs in detail. The sharply pointed, strongly projecting beard, diadem, round beads, and hair contour find parallels in other Tarantine terracottas. The hole pierced behind the mouth, in the reverse, may have served for hanging the piece up in the sanctuary. Dionysos may be an appropriate identification for this head, because of the beard.

DETAILS

CONDITION

Fragmentary. Broken at neck level. Incrusted.

TECHNIQUE

Clay Pinkish grey color with fine mica. Mold-made; reverse is concave; it shows traces of tooling. A small hole was pierced vertically through the piece behind, in the center, starting at lip level. The beard apparently was made separately and attached.

COMPARANDA

The headdress is similar to EA-1989-19 and EA-1989-22a, but differs in detail. A close stylistic comparison is a head on sale at Sotheby's (compare diadem, round beads, hair contour, *Catalogue, June 10 and 11, 1983* no. 73) and British Museum no. 1262, Higgins, *Catalogue, Br. Mus.,* p. 343, pl. 173; and also F. Winter, *Die Typen der figürlichen Terrakotten,* (Berlin, 1903)i, 199, no. 4. The sharply pointed, strongly projecting beard finds parallels in other tarantine terracottas: see Winter, *op. cit.* i, 199, no. 1 for the sharp point; Helga Herdejürgen, *Die tarentinischen Terrakotten des 6. bis 4 Jahrhunderts v. Chr. im Antikenmuseum Basel* (Basel, 1971) no. 17, pls. 3 and 6 for the strong projection.

56 ANN ASHMEAD

WESTERN GREEK TERRACOTTA: RECLINING BEARDED BANQUETER, TARANTO

Plate: 60
Accession number: EA-1989-19
Date: Mid fifth century B.C.
Source: Purchased from the Chapman Estate
Dimensions: Pres. H., 0.165 m.; Pres. W., 0.100 m.

This reclining banqueter is similar to Haverford terracotta EA-1989-20. See EA-1989-20 for a discussion of the type and its identification, but the beard suggests Dionysos as a more appropriate identification for this figure. A comparison of the two terracottas (EA-1989-19 and 20) points up other differences besides the beard, notably in the headdress, face shape, couch design, and anatomical markings.

Here a male banqueter reclines on his left side, on a couch, supporting himself on his left elbow, which rests on a pillow. His right arm is draped on his raised right leg, which is bent; in his left hand he holds a phiale against his body. He wears a himation which covers him from the waist downwards. His hair arches over his forehead and falls on his shoulder. He has an oval face, projecting nose, a large projecting beard with round contour, and tooling above mouth for a moustache(?). He wears a beaded diadem and a stephane (a metal hair-ornament in the shape of a crescent-shaped band tapering towards its ends); on its raised central portion is a large dot-in-circle in relief (a rosette?), which is the base of a lost lotus (or palmette) ornament. His couch originally stood on high legs, which were cut off; the upper leg has a round, turned upper element and was higher than the lost lower leg, in order to serve as a headrest. Covering the couch leg is a thin mattress, overlaid by a thicker mattress, above which is a rectangular pillow under the diner's elbow.

This terracotta was made to stand upright by means of a vertical strip of clay, attached as a support strut to the back behind the pillow and bed leg.

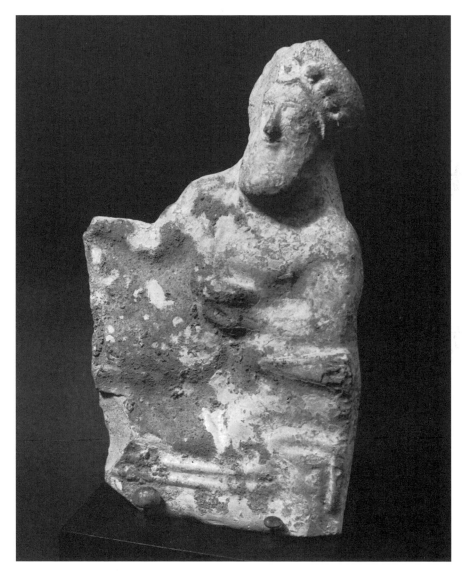

Figure 60 EA-1989-19. West Greek terracotta. Reclining banqueter. Mid-fifth century B.C.

CONDITION

Fragmentary. The l. half of the piece (the foot of the couch, banqueter's legs) is missing; the r. side of the head is broken off. The couch legs were sawed off smoothly, as was the lower half of the support-strut in back. Incrusted front.

TECHNIQUE

Clay Creamy gray color with fine mica. The front of the figure is mold-made. The hand-smoothed back is somewhat concave; there is the impression of thumb print in the middle of the support strut. The area behind the head is hollow. *Color* White slip. Pink on flesh.

BIBLIOGRAPHY

Unpublished

COMPARANDA

For the shape of the couch, British Museum no. 1262, Higgins, *Catalogue Br. Mus.,* pp. 343–344, pl. 173 and F. Winter, *Die Typen der figürlichen Terrakotten,* (Berlin, 1903)i, 199, no. 4; no. 5. For similar central rosette in a beaded band, see British Museum no. 1262 (Higgins, *op. cit.* and Winter *op. cit.,* i, 199, no. 5.). The type is Clelia Iacobone, *Le Stipi Votive di Taranto* (Scavi 1885–1934) (Rome, 1988), C, XV, p. 59, pl. 48.

ANN ASHMEAD

WESTERN GREEK TERRACOTTA: PROTOME OF A GODDESS: PERSEPHONE(?) SICILY OR SOUTH ITALY(?)

Plate: 61
Accession number: EA-1989-21
Date: First half of the fourth century B.C.
Source: Unknown. Chapman Estate perhaps(?)
Dimensions: Pres. H., 0.179 m.; Pres. W., 0.120 m.; Depth, at nose, 0.045 m.

This terracotta woman—goddess or worshipper—was probably once a votive offering at a shrine in Sicily.

A new type of female protome, with non-molded back, wearing a polos (cylindrical headdress), with wildly waving hair appeared in Sicily about 400 B.C. The Haverford terracotta's distinctive style of wildly waving, back-swept hair has some affinity with the hair of these Sicilian protomes, but unlike the latter, greater emphasis is placed on the polos, by its grand size.

The woman's polos, very wide and flaring, dominates her head. Her wild back-swept hair is center-parted. She has a squarish face, eyes possibly with tear ducts indicated, broad round chin, and generous mouth. She wears a chiton with a V-neckline and a himation, framing her face, apparently pulled over her polos which has straight sides that cant outwards. She wears disk earrings with tear-shaped pendants. The terracotta is a protome (hollow-backed), not a shoulder bust (with back).

There is major debate among scholars as to the identity of the woman represented. Many consider her a goddess—because of the polos, the characteristic adornment of goddesses. Scholarly tradition favors an identification with the chthonic divinities—Demeter, the Mother Goddess of the Earth, or her daughter Persephone—both of whom were greatly honored by the Greeks of South Italy. Malcolm Bell, excavator of Morgantina, identifies her as the goddess Persephone, choosing the daughter over the mother on the basis of the presence of a veil, a reference to Persephone's marriage with Hades. The veil is an allusive symbol that can denote sorrow or generalized domestic modesty, but its most frequent association is with marriage. Although the Haverford protome lacks a veil, here the himation is pulled over the head as a shawl, and is indistinguishable from a veil. Other scholars argue for another goddess (Athena, Hera, Aphrodite, or Artemis) or a nymph, worshipped in caves; or suggest that she is an image of the dedicator.

The Archaic protome was developed out of non-Greek eastern prototypes; an Egyptian relationship with mummy masks is advanced. Protomoi are common, not in graves, but in votive deposits and sanctuaries. Their Archaic presence at a site does not prove an exclusive devotion to a preferred divinity but is rather evidence of trade patterns.

The protome was usually supplied with suspension holes for hanging up, either inside shrines or perhaps on trees in sanctuaries; but the Haverford terracotta, since it lacks a hole, presumably leaned against a sanctuary wall.

The shape of her face (broad, with heavy chin) seems to date from the first half of the fourth century.

CONDITION

Broken, mended. Lower arms are missing. Chipped on polos rim. Incrustation around face and on back.

TECHNIQUE

Clay Pale orange and brown color with mica. Molded head and upper torso of a woman, with hollow, non-molded back.

BIBLIOGRAPHY

Unpublished

COMPARANDA

For the waving hair, see Higgins, *Catalogue, Br. Mus.*, p. 297; compare to no. 1188, p. 321, pl. 162, a terracotta from Sicily; Morgantina, no. 96b Malcolm Bell, III, *The Terracottas: Morgantina Studies,* I (Princeton, 1981), pl. 32.

For the polos: Archaic protomes from Gela display a flaring, very tall polos; compare to J. Uhlenbrock, *The Terracotta Protomai From Gela: A Discussion of Local Style in Archaic Sicily* (Rome, 1988) pp. 161–164, pls. 18–19.

On Veil's significance: M. Bell, *op. cit.*, p. 84.

On the identification of the woman see Martin F. Kilmer, *The Shoulder Bust in Sicily and South and Central Italy: a Catalogue and Materials for Dating* (Götenborg, 1973) pp. 67–70; and Malcolm Bell, *op. cit.*, pp. 81–85. Uhlenbrock discusses the origins and religious signification of Archaic protomes' origins (*supra*) pp. 139–156. She believes that the evidence of protome distribution militates against the identification of the protome with one specific goddess (cthonic or otherwise), the distribution is linked to trade, rather than cult. See also, Jaimee P. Uhlenbrock, "History, Trade and the Terracottas," *Expedition* vol. 34 (1992) pp. 16–23. On p. 21 she discusses the identification of the seated female type wearing a polos from the sanctuary of Demeter and Persephone at Cyrene.

See J. P. Uhlenbrock, *The Terracotta Protomai From Gela: A Discussion of Local Style in Archaic Sicily* (Rome, 1988) pp. 161–164, for extensive recent bibliography.

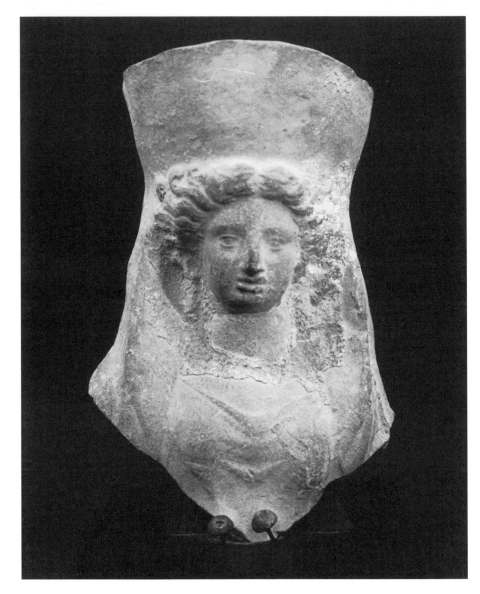

Figure 61 EA-1989-21. Western Greek terracotta. Female protome. First half of the fourth century B.C.

Index

Concordance